SPOCKOLOGY

ESSAYS ON SPOCK AND LEONARD NIMOY FROM THE UNDISCOVERED COUNTRY PROJECT AND FRIENDS

EDITED BY
KEVIN C. NEECE

Collection © 2015 Kevin C. Neece

All rights reserved. No portion of this book may be reproduced, stored in a retrieval system, or transmitted in any form or by any means—electronic, mechanical, photocopy, recording, scanning, or other—except for brief quotations in critical reviews or articles, without the express permission of UCP Press.

Cover design, cover art, layout and typography
by Kevin C. Neece.

Front cover art based upon the font, Prime Directive.

Back cover art based upon *U.S.S. Enterprise* rendering by Charles Casimiro Design. (charlescasimiro.com)

This book uses Book Antiqua, Airborne, and Roddenberry fonts.

Published by UCP Press, Fort Worth, TX, via CreateSpace.

First Edition, September 2015

ISBN-13: 978-1-5061-0817-9

ISBN-10: 1-5061-0817-2

For Leonard.
 — KCN

Table of Contents

Notes on the Contributors ix
Introduction xv*

2011

1. October 2nd 3
 T'NARA VALDRIN KELENSA

2. Interview with T'Nara Valdrin Kelensa 6
 KEVIN C. NEECE
 - Part 1: Why I Love Star Trek
 - Part 2: Why I Love Spock
 - Part 3: Spock and Christ
 - Part 4: Why I Love Leonard Nimoy

3. Being Human 15
 SCOTT HIGA

4. Mom, Dad, and Mr. Spock 18
 LISA M. LYNCH

5. St. Spock of Vulcan: Patron Saint of Star Trek 23
 KEVIN C. NEECE

6. St. Spock of Vulcan: First Christ Figure of Star Trek** 26
 KEVIN C. NEECE

2012

7. Spock, the Light of the Romulans 31
 MICKEY HAIST, JR.

8. The Wisdom of Spock: 10 Life Lessons From Everyone's Favorite Vulcan 39
 NEIL SHURLEY

9 True Confessions of a Gen-X Trekkie 44
SHANNA GILKESON

10 In Defense of "Spock's Brain" 49
MATTHEW WEFLEN

11 The Softer Side of Spock 53
RENEA MCKENZIE

12 The Works of Spock's Hands... and Ours 57
MIKE POTEET

2013

13 Spockrates and the Nature of the Emotions 65
MARK J. BOONE, PHD

14 In Search Of... 67
MIKE POTEET

2014 | 2015

15 Mr. Spock, Scientist 73
A. BOWDOIN VAN RIPER

16 Punk on the Bus: An Encounter with Christ in *Star Trek IV** 77
KEVIN C. NEECE

17 Spockrates: The Meaning of Plato's *Republic*, and the Meaning of Life* 85
MARK J. BOONE, PHD

18 Not As Happy a Birthday** 88
HANK HARWELL

19 Spock and Jews in the 1960s* 91
YONASSAN GERSHOM

20 Making Mr. Spock's Ears* 96
 STEVE NEILL

21 How Leonard Nimoy Saved My Life* 100
 T'NARA VALDRIN KELENSA

22 Being Leonard Nimoy 103
 NEIL SHURLEY

 * PREVIOUSLY UNPUBLISHED MATERIAL
 **INCLUDES PREVIOUSLY UNPUBLISHED MATERIAL

Notes on the Contributors

Mark J. Boone, PhD, is a teacher and researcher in philosophy, especially the hisory of philosophy, primarily the ancient and medieval eras. Mark earned his B.A. in Biblical Studies and Philosophy from Dallas Baptist University in 2005 and his PhD in Philosophy from Baylor University in 2010, writing his dissertation on Saint Augustine. The book version, *The Conversion and Therapy of Desire: Augustine's Theology of Desire in the Cassiciacum Dialogues*, is forthcoming from Wipf and Stock Publishers. After teaching at Berry College in Rome, Georgia, for two years, Mark became the Assistant Professor of Philosophy at Forman Christian College. He is an occasional book reviewer for the journal Augustinian Studies and has written articles dealing with Plato, William James, theology and the arts, and epistemology. In some of his precious little spare time Mark makes animated cartoons based on famous speeches and dialogues in the history of philosophy, available in YouTube and Vimeo under the user name TeacherofPhilosophy. He is also, along with Kevin C. Neece, co-editor of *Science Fiction and The*

Abolition of Man: Finding C.S. Lewis in Sci-Fi Films and Television, forthcoming from Pickwick Publications.

Yonassan Gershom is a rabbi and freelance writer. His books include *Jewish Themes in Star Trek*, which further explores the parallels between Jews and Vulcans, as well as other Jewish influences on the Star Trek universe. His blog, TrekJews.com, explores that topic, and includes an annotated link launcher to articles about Jews and Trek. He lives with his wife, Caryl, on a 15-acre hobby farm in northern Minnesota, along with a plethora of cats, dogs, guineas, chickens, and wildlife.

Shanna Gilkeson's love for Star Trek inspired her to pursue a career in television, writing, and teaching. At the time of her Spocktober contribution, she was an undergraduate at Eastern Michigan University. Today, she is pursuing a PhD in Media and Communications at Bowling Green State University. Her interests include gardening and freshwater aquariums. Shanna lives with her two cats, Squiggy and Sherman.

Mickey Haist, Jr. is a lifelong Star Trek fan, currently writing for his Master's in Theology. He used to write the blog Geeks of Christ, but now spends his days attempting to read heavy old books at warp speed (but usually achieving a manageable one-quarter impulse). His favorite Star Trek episode is "Who Mourns for Adonais?" He lives with his wife and too many cats in Montreal.

Hank Harwell is a local leader for an international religious movement and faith-based charity. Sporting a degree in Radio/Television Film, he is also the person responsible for the Geekklesia blog (geekklesia.blogspot.com), where he attempts to reconcile his faith with his love for speculative fiction. Connect with him on Twitter at @cleireac.

Scott Higa lives in southern California where he works as a youth pastor. In 2011, he combined his love for Jesus and his love for Star Wars by creating The Christian Nerd (thechristiannerd.com),

a daily blog and podcast that examines the intersection of the Christian faith and nerd culture. His earliest memories include growing up in Christian home and watching Return of the Jedi in the theater when he was four years old. The fact that God's story of redemption regularly appears in nerd culture fascinates Scott; the best stories, nerdy or not, reflect the greatest story of all time. Scott's favorite Star Wars movie is *The Empire Strikes Back*, his favorite episode of *Star Trek: The Next Generation* is "The Perfect Mate," and his favorite comic book is *Uncanny X-Men #275*. He is married to Alycia and together they are responsible for Elphie, a Yorkshire terrier.

T'Nara Valdrin Kelensa is a Vulcan/Romulan/Klingon friend of The Undiscovered Country Project. She has a deep appreciation for Spock and Leonard Nimoy and was the official UCP correspondent to Nimoy's final convention. She credits Star Trek and Leonard Nimoy with saving her life and inspiring her to pursue a career in film and television. This fall, she will begin her studies in Broadcasting and Digital Media and would love to one day produce her own, original Star Trek series.

Lisa M. Lynch lives outside of Portland, Oregon and is a small business owner. She previously worked at the Smithsonian Institution in Washington, D.C. and has had experience in preserving and documenting historical papers and artwork. She also enjoys writing in her spare time and has contributed to Trek.fm. Lisa's interest in Star Trek began in 2009 after her husband invited her to watch the new J.J. Abrams Star Trek movie as a long lunch date. She left the movie fascinated and decided to watch the original series to compare notes. Starting with episode one, she remained in a Trek trance until the final episode, and has never really recovered. Her bemused family occasionally indulges her with Trek-related gifts. She tries not to talk about it too much in front of them; instead she leans on Twitter (@StarTrekWreck) for support.

Renea McKenzie earned a Masters' degree for her studies in literature and is currently doing graduate research in African American Literature and History. Prior to starting her current work, Renea spent a year studying at the famous L'Abri Fellowship in Switzerland. She is a self-professed "armchair Trekkie" and is the Editor of Thinking Through Christianity (thinkingthroughchristianity.com) where she and her writers explore the intersection of faith and (pop) culture. Renea takes great pleasure in leading a very talented creative writing group at her church and swing dancing at the historic Sons of Hermann Hall.

Kevin C. Neece is the author of *The Gospel According to Star Trek* (Forthcoming, Cascade Books, 2016) and a speaker on media, the arts and pop culture. He also founded The Undiscovered Country Project (undiscoveredcountryproject.com), an ongoing voyage through Star Trek from a Christian worldview perspective. He is a contributing editor for *Imaginatio et Ratio: A Journal of Theology and the Arts* and his work has appeared in in the book *Light Shining in a Dark Place: Discovering Theology Through Film*, *New Identity Magazine,* the Art House Dallas blog, and Patheos, among others. A former professor, Kevin holds a BAS in Communication and Philosophy and earned a Masters' degree for his studies in Fine Arts. He lives with his wife and son in Fort Worth, Texas. Connect with Kevin and The Undiscovered Country Project at kevincneece.com, on Twitter (@KevinCNeece, @UCPTweets) and on Facebook.

Steve Neill has been involved in motion picture visual effects for almost forty years, producing makeup effects, creature effects, props, models and CGI for major motion pictures, television, and documentaries. He is also a well-known Hollywood "gorilla man," creature actor and puppeteer. His film credits include *Ghostbusters, Fright Night, Laserblast,* and *Star Trek VI: The Undiscovered Country*. He also holds the distinct honor of having sculpted Spock's ears for *Star Trek: The Motion Picture*. He and his partner, artist Mary Cacciapaglia, own and operate SNG Studio & Gallery in Ventura, California, where they continue to make

magic happen, doing custom builds and making sci-fi films. Join them on their adventures at steveneillsgarage.com.

Mike Poteet is an ordained minister in the Presbyterian Church (U.S.A.) currently serving the larger church as a freelance writer of Christian education materials. He has authored several literature study guides for Christian publisher Progeny Press. He's also placed short stories in two professional anthologies: *Star Trek: Strange New Worlds II* (Pocket, 1999) and *Leaps of Faith: An Anthology of Christian Science Fiction* (The Writers Café Press, 2008). He and his wife met at the College of William and Mary. They both earned Masters of Divinity from Princeton Theological Seminary. They live in the suburbs of Philadelphia, PA, and are the proud parents of two young padawans. You can find Mike on Facebook and Twitter (@Bibliomike).

Neil Shurley is a writer, actor, musician and composer who describes himself as a "ukulele evangelist, coffee achiever," and "semi-professional nerd." He likes to write. Neil has published personality profiles, news reports, blog posts, and specialty real estate items as well as previews, reviews and interviews about theatre, film, dance, and music. Some of the publications he has written for include *Greenville News*, *Greenville Journal*, *Creative Loafing*, *MetroBeat*, *GSA Business Journal*, *Presbyterian News Service*, *Film Score Monthly*, *All Music Guide*, and *The Examiner*. In addition to plays, documentary and promotional films scripts and fiction, he has also authored a history book, *Growing Greenville for Fifty Years: A Celebration of Greenville Technical College*. Learn more on Twitter at @ThatNeilGuy.

A. Bowdoin Van Riper is a historian who writes about modern science and technology, and images of science, technology, and history in popular culture. He's the editor of Rowman & Littlefield's "Science Fiction Television" book series, and Web Coordinator for the Center for the Study of Film and History. He has a PhD from the University of Wisconsin—Madison, and is the author or editor of 10 books (so far). His physical self resides

on the coast of Massachusetts, and his virtual self at www.abvr.net.

Matthew Weflen is the co-founder of Treknobabble, a blog featuring "Star Trek reviews, discussions, podcasts, and links for nerds by nerds." Matthew has been a fan of Star Trek since about 1986, when *Star Trek IV* hit the theaters. At the tender age of 9, Star Trek forever altered his worldview. He watched all of the following series with his family and then with his friends, and then 4 or 5 times on his own, to boot, before hooking his wife in 2005. Thankfully, by then, he no longer needed his worn-out VHS copies, taped off of broadcast. When not frittering his time away on this site, Matthew is an adjunct professor of Philosophy at St. Xavier University in Chicago. He also teaches at Wilbur Wright College. He is finishing his Ph.D. work in same at Marquette University. If he isn't summarily granted control of the Trek franchise by the acclamation of his peers, he'll probably end up teaching full time with said doctoral degree.

Introduction

This book is about all things Spock. From the meaningful to the mundane, from the broadest ideas to the smallest details, the writers whose work these pages contain have all come together around this singular Vulcan, who is, after 50 years, still the most iconic figure in Star Trek.

I began The Undiscovered Country Project in 2011 to share my ongoing voyage through Star Trek from a Christian worldview perspective with others, but also to express my general love of Star Trek. In October of that first year, I was shocked when Leonard Nimoy announced his retirement from appearing at Star Trek conventions (at the time, he was supposedly also retiring from acting, but he went on to make a final appearance as Spock in *Star Trek: Into Darkness*). I decided I should do something to honor the work of Leonard Nimoy and the importance of Spock—my own small tribute to commemorate this moment in Trek history. So, I declared that October to be the first Spocktober!

I began gathering scraps of interesting information to share about Nimoy and Spock, invited several friends and people I admire to contribute blog posts, and even invited visual effects and make-up artist Steve Neill to donate two pairs of Spock ears, made from his original molds that he sculpted for *Star Trek: The*

Motion Picture. (He graciously accepted.) The event was a huge success and I enjoyed it so much that I decided to make it an annual fixture on the UCP website. The giveaway was the most visible portion of the event and has remained so in the ensuing years, but the part I really enjoyed was reading and hosting all the wonderful blog posts that were submitted.

While my site and my overall focus come from a Christian perspective, these contributions were open to any and all subjects relating to Spock or Leonard Nimoy. I received many wonderful submissions and have shared them all on the website, but as time has gone on, I've felt I'd like to draw more attention to these pieces. So, I decided to collect them together and share them as a book. What you now hold in your hands (or read on your screen), then, is the complete collection of four years of Spocktober guest posts. Contributors include Matthew Weflen of Treknobababble, Scott Higa of The Christian Nerd, Lisa M. Lynch of Trek.fm, Renea McKenzie of Thinking Through Christianity, Mike Poteet of The Sci-Fi Christian, Mickey Haist, Jr., of Geeks of Christ, T'Nara Valdrin Kelensa and Shanna Gilkeson. They are gifted writers and generous interview subjects—some scholars, some students, all fans. It has been my joy and honor to curate these excellent and unique pieces at the Undiscovered Country Project website, and it gives me great pride and pleasure to present them to you here.

A collection of guest blog posts is all this book was initially intended to be. But then, in February of this year, I was shocked again. I had known Mr. Nimoy was in poor health. In fact, I had retooled Spocktober 2014 to include a focus on COPD awareness and smoking cessation, following his announcement that he had been diagnosed with the disease. "I quit smoking 30 yrs ago," he had posted to Twitter that January, "Not soon enough. Grandpa says, quit now!! LLAP."[1] But I had hoped, as we all had, that he would not be overcome by his illness nearly as quickly as he was. Rarely has a death been felt by so many. There were outpourings of grief and love, not just from the Star Trek

[1] https://twitter.com/therealnimoy/status/428720437711736832

and sci-fi communities, but also across cultural divides and around the world. As many commentators noted, Leonard Nimoy lived long and certainly prospered, but still, it seemed too soon. Consider how much longer and richer his life might have been and what a loss that is to his family and to this world. Don't smoke, kids. Grandpa says.

When the news of his death broke, I decided to reach out to a few more people and see if we could do a little more with this book. I was very happy to get some positive responses and to be able to share new, mostly previously unpublished pieces by my UCP Science Officer (and resident philosopher) Dr. Mark J. Boone, Hank Harwell of Geekklesia, consummate nerd writer Neil Shurley, and my new friend, Rabbi Yonassan Gershom, a traveler along similar roads to mine as the author of *Jewish Themes in Star Trek*. This collection also includes a revealing new essay by T'Nara Valdrin Kelena, whose interview and essay were part of the first Spocktober. Our friend Steve Neill has graciously allowed me to include his recounting of his experience making Spock's ears for *Star Trek: The Motion Picture* and I've also included some of my own, previously unpublished work. I'm honored again by these new contributions and the generosity with which they have been shared.

I hope you enjoy *Spockology* and may Spock, the memory of Leonard Nimoy, Star Trek and especially you, dear reader, **Live Long and Prosper!** (John 10:10)

Grace and Peace,
Kevin C. Neece
Author, *The Gospel According to Star Trek*
(Forthcoming, Cascade Books, 2016)

2011

1

October 2nd

T'Nara Valdrin Kelensa

October 2, 2011: it's a day I will remember for the rest of my life. On that day, something that I never thought possible happened. At approximately 3:50pm, I walked into a room. The room itself wasn't very remarkable or memorable, but what – or who – was inside of it is: Leonard Nimoy, the man, the myth, the legend. Yeah, I kind of had to say that!

I think October 2, 2011 might possibly go down in history among Star Trek fans because it's the day that Leonard Nimoy attended his final convention, but it's going down in my more personal history too.

What was it like? Well, I could say that it was "amazing" or "fantastic" or "perfect" and while it *was* all those things, those words can't even *begin* to describe what it was like. Saying those words described what it was like to meet Leonard Nimoy would be like saying "kind of deep" is all you need to be able to describe the ocean, or that "kind of big" is all you need to describe the

universe. I had, at most, 12 seconds with him, but those 12 seconds were the best 12 seconds of my life! It was like I had forever, but it only lasted a moment. Either that or I had a moment and it lasted forever.

I can give you the facts, but does that really tell what it was like meeting Leonard Nimoy? For those of you who haven't met him, all it does is make you think you understand the wonder of that moment.

Before he walked onstage at 1:50, I was tense with anticipation. Soon I would be in the same room as Leonard Nimoy. I'm still not sure exactly what I was feeling. Was I excited? Nervous? Happy? Terrified? All of them at once? Whatever it was, when I finally saw him, I stood up and screamed and cheered as if my life depended on making celebratory noise.

For an hour, I listened to that wonderful voice as Mr. Nimoy gave an emotional presentation, telling us about his search for honor, his acting career, his photography, etc. It was hard for me to concentrate on the actual words, I was so focused on the fact that finally I was listening to him live – not a recording made by somebody else, not listening to somebody else tell about hearing him, no! I was there! I kept having to pinch myself, remind myself that this wasn't another dream.

Immediately after his speech, I left the theater and joined the long line of people waiting to have a picture taken with Mr. Nimoy. I thought I'd felt all the emotions I was going to feel in connection with meeting Leonard Nimoy, but as I got closer to that room, to *the* room, I wasn't quite as certain.

When I finally entered the room, with only a few people in front of me, I was terrified! What if I couldn't say anything to him, and what if I *did* say something to him and it came across completely wrong?

Then I was the next person, and I was caught up in the moment. I didn't have time to feel nervous; I didn't have time to worry. I stepped up and before I knew what I was doing, I was giving Leonard Nimoy a hug. I wanted to kiss him too and I think that is the only regret I have: that I didn't have the courage to do it.

We posed for the picture, and then I stood in front of him. I wanted to thank him for being such an amazing person and for helping me personally in my life, not as Spock, but as Leonard Nimoy. He took both my hands in his and squeezed them gently, even as the convention people were pushing me away. "I'm glad we were able to help" he told me as I was pushed out of the room. And then my moment with Leonard Nimoy was over.

Certainly by this time, the number of emotions that Leonard Nimoy was able to stir in me was at its peak! But as I was walking away, I felt tears behind my eyes. Normally when I feel that tears are going to fall, I fight against them, but by this time I didn't. Don't ask me why I didn't, but all I know is that Leonard Nimoy is able to stir emotions in me, when I've always felt that I could never feel real emotions.

I cried for 30 minutes. Were they tears of joy that I'd actually met Leonard Nimoy? Were they tears of sorrow that he was never going to go to another convention? Were they all the tears that I'd held back over the years? I don't know now, and I don't think I'll ever know.

So what was it like meeting Leonard Nimoy? What was it like seeing him live? Maybe the best one-word answer to those questions is "emotional." I will treasure the memory of that weekend forever.

I think I learned something that weekend that I didn't expect to learn. I thought I knew it already, but when I experienced it, I realized I knew nothing. Leonard Nimoy might be known for playing an unemotional person, but unemotional is *not* how I would describe the people he touches. He can move us to tears, bring us to laughter. He reaches for our hands, and touches our hearts.

2

Interview with T'Nara Valdrin Kelensa

KEVIN C. NEECE

Part 1: Why I Love Star Trek

T'Nara Valdrin Kelensa, our special Vulcan correspondent to the October 2, 2011 Star Trek Convention in suburban Chicago wrote a very personal piece regarding her feelings on finally getting to meet Leonard Nimoy. I wanted to know more about where all the emotions she describes in that piece came from, so I asked T'Nara to do an interview with me by e-mail. The following is the first in a series of posts recounting that conversation.

Q: I know this was not only your first meeting with Mr. Nimoy, but your first Star Trek convention. Tell me a bit about that experience and your first impressions of the convention. Was it what you expected?

A: Well I wasn't exactly sure what to expect, but it was amazing in every sense of the word. I walked in the hotel with my pointy ears on, and immediately ran into a Starfleet officer who gave me the Vulcan salute! I think my mom, who accompanied me, probably felt a little bit out of place, but I felt right at home amongst the Klingons, Borg, Vulcans, Romulans, etc. It was amazing to go sit in the theater and wait for the different stars to come out, and of course listening to everyone speak was a delight. I remember thinking on Saturday, which was my first day there, that the only thing keeping the day from being absolutely perfect was the lack of Leonard Nimoy.

I think the con was only the second place in my life where I've truly felt at home and able to be me without any reservations (the first being on stage). The Star Trek family is probably the quirkiest in the world, but I absolutely adore being a part of it!

Q: I'm glad you felt so at home. What is it about the Star Trek universe that attracts you in that way?

A: Because it's the place where "weird" is normal! LOL Seriously, though, that is a big part of it. All my life I was the "weird" one. Something about me was just different from my friends. We had different interests, different agendas, different ideas, thoughts and feelings. I didn't even dress the same way my friends did. Not that it bothered me much; I was just different. It's who I was. I think the one word I've been described with consistently throughout my life has been "weird." Then one day I discovered Star Trek.

I started watching Star Trek with *The Wrath of Khan*, and was immediately hooked. I've always adored stories dealing with sacrifice, and so Spock's sacrifice at the end drew me in and made me a fan. Then I watched more, and I realized that he was a lot like me. He was different from everybody else in almost every way, and yet he fit in *as* the different person.

Next, I discovered my fellow fans and realized that all of my being "different" and being "weird" was just preparing me to fit in with them! I don't think there is a "normal" Star Trek fan out there. Now there are people I can associate with who have

the same interests, thoughts, ideas, etc. And what's even better about it is that we are different in our similarities, and we all love that!

When I'm amongst other Star Trek fans, I'm just as "weird as I've always been, but I'm not different anymore. People around me still affectionately call me "weird" but I love the word now, because I'm part of the "weird" family of Star Trek.

Q: Weird is one thing, but Star Trek weird is another. Is there something more than weirdness that draws you to the Trek universe and community?

A: Oh yes, Star Trek weird is *totally* different from weird, which is why I put the word in quotation marks. It's the best word I could use, even though it doesn't *really* describe the "Star Trek weird."

There are just so many levels of why I love being a Star Trek fan. Of course the shows and movies themselves are amazing! I love most of the characters, most of the stories, and the fictional universe itself. It's seriously kind of difficult to put into words what is so amazing about this universe and my fellow fans. Everybody is just so friendly, so passionate, so wonderful!
I like that we, as a group, are so diverse, and I'm pretty sure we're the only group in the world who will spend hours debating the finer points of Klingon honor!

I love that we can and do debate the different elements of Star Trek, that we all have our own opinions and we all enjoy that our opinions are all different. Trekkies make the term "cheerful argument" make a whole lot of sense! We debate costumes, characters, episodes, entire series, and there is always and undercurrent of respect and affection, even in the most heated discussion.

And maybe *that* is what I really love about being part of the Star Trek fan family. There is an honest respect for each other, and a mutual affection in spite of our differences of opinion.

Part 2: Why I Love Spock

In part 2 of my interview with T'Nara Kelensa, I wanted to know more about her love of Spock as a character and what drew her to him.

Q: You mentioned Spock and his sacrifice in *The Wrath of Khan* and that it was that aspect of the character that first drew you to him. Talk to me a bit about that and why you love Spock the way you do.

A: Well, let me expound on the loyalty thing a bit first. I've always loved stories of loyalty because loyalty is one of the most important things, in my opinion, that people can display toward each other. I've always adored reading and my favorite books, to this day, have been books where loyalty between the characters is a big part of the story, or where the loyalty is what the story springs from. *Where the Red Fern Grows*, *Island of the Blue Dolphins*, and *Lord of the Rings* are the books that stand out the most for me.

When I sat down to watch *The Wrath of Khan*, I was planning on hating it. I knew that Star Trek existed and that my dad liked it, but that was it, and I didn't want to know anything more. The only reason I sat down was because I was tired and that was the movie my siblings wanted to see.

Then the story began. It interested me, Khan and his desire for revenge, Kirk's feelings on growing old, etc., but I'm not sure if that would have been enough to make me a fan.

Then I saw that the ship was in danger. I saw Spock sit in his chair and think for a minute, then get up and leave the bridge. I thought nothing of it... until he entered that radiation chamber. I sat there in slight shock as Spock fixed the warp drive, wondering how painful it was for him to do this. I watched when Kirk tried to get to his friend only to learn he was already gone, and then felt a smidgen of hope when Spock pulled himself to his feet. Then I heard Spock's explanation for what he had done: it was because he preferred to die a painful death if his friends would live than to die quickly and know that they would die with him. Although I didn't cry, that revelation touched my heart, and it is what started my "trek" to fandom.

Next came the long, and I mean *long* year in which I saved up my money to buy The Original Series, but that didn't stop me from learning and loving. And then when I finally bought TOS, I loved it even more.

As I mentioned earlier, I was always the different one, and that is something else that attracted me to Spock. Here was this alien, the only alien, on this starship full of humans. He is different not only here, but everywhere he goes. He is the son of two aliens, and will be different no matter where he is. If there was one person in the universe who had the qualifications for being the loneliest person you could ever find, Spock has them. To name a few examples:

> He is alien, no matter where he goes.
> He can't express himself in ways people would understand.
> He refuses to let down his ice cold barriers.

And yet, in spite of this, Spock is not alone. He has found a way to fit in just as he is. He has close friends among his crew mates, especially Kirk and McCoy. As I said earlier, Spock found a way to fit in *as* the different person.

That is very appealing to me, because, as I said earlier, I too was always the different person. I was able to relate to Spock on so many levels, and I felt he was inwardly asking himself the same questions I was asking myself. Am I being too emotional in this or that given situation? Should I have said something? Should I have said nothing?

Those are questions that most people ask themselves at one point or another, and I felt very connected to the character because of that.

So, from the first, he touched me with his loyalty. Then he appealed to me because of his loneliness. And then he showed me that I wasn't the only one who was having trouble connecting with other people, but he showed me that it is 100% possible.

And people sometimes wonder why I love him so much?

Part 3: Spock and Christ

In part 3 of my interview with T'Nara Valdrin Kelensa, I ask her to delve deeper into some areas that seem to indicate connections she is making between Spock and Christ.

Q: I love your thoughts on Spock's loneliness. That's a wonderful insight. It's a beautiful idea that Spock's loneliness finds completion in giving himself for those he loves. I'm reminded of the Biblical description of Jesus as a man of sorrows who was acquainted with grief. Do you think Spock's resonance with Christ in this regard has affected the way you view the character? Has your faith consciously (or unconsciously) informed your experience of Star Trek?

A: I don't think my faith has affected how much I love Star Trek, but I certainly do love all of the connections between the two. You decide if that answers whether my faith has consciously or unconsciously informed my experience of Star Trek.

As to the first question, that one is a bit harder. There are actually many connections, in my opinion, between the character of Spock and Jesus. I love how Spock's character took on a messianic type of role in the movie series. The first obvious connection is that Spock was a willing sacrifice for those he loved. I might religiously geek out on your for a minute, but bear with me.

I think that *The Search for Spock* is possibly one of the most subtly religious Star Trek productions ever made, with a ton of Christian references. First, we get the friends of Spock (who is analogous with Jesus) mourning the death of their savior. On the Genesis planet we see that after Spock's death, we get life from lifelessness. I wonder if that's supposed to be analogous for the fact that, after Jesus' death on the cross, we were saved from the death of sin and brought to life. Saavik (who is Spock's protege/student/...disciple) and David find the empty casket, with nothing more than Spock's burial robe... sound familiar? Jesus' disciples found an empty tomb with nothing left but His burial clothes.

On Kirk's side of the story, we have people saying there is no possible way that Spock could somehow be returned, and refuse to let Kirk see if it is indeed possible, perhaps analogous with the Jewish priests who accused Jesus' disciples of stealing Jesus' body and trying their best to stop them in spreading the word that Jesus is God.

Perhaps I'm looking into that movie a little bit too much, but those are some of the very interesting Christian connections that I see.

I'm not sure if that in itself exactly answers your question, but I think putting it all down in words does for me. Perhaps from the first I didn't see all of this and even though I don't think my love of Star Trek as a whole was affected by my faith, perhaps my singling out of Spock for my affections did subconsciously come from my faith.

Part 4: Why I Love Leonard Nimoy

In part 4 of my interview with T'Nara Valdrin Kelensa, we come around to Leonard Nimoy himself and why he has inspired her personally in such a profound way.

Q: The other thing I'm curious about are your thoughts on Mr. Nimoy himself. You mentioned in the piece that you wrote that he is inspirational and important to you as well, not just Spock. Can you elaborate on that a bit?

A: I will admit that the only reason I know of Leonard Nimoy's existence is Spock. After watching *The Wrath of Khan* and being infected with the Trekkie virus, I started looking up the different actors. Of course, because of my immediate affection for Spock, Leonard Nimoy was first on that list.

The first thing about him that made me start loving Leonard Nimoy the man just as much as, if not more than, Spock the alien was his dedication to what he does and his integrity. Although I didn't learn this until later, he had to work extremely hard to get what he wanted. There were setbacks, times when he

was more known as "the fish doctor" than an actor, but he kept trying, kept working and eventually, he succeeded.

And that success is named Spock.

But his hard job of working to succeed wasn't over yet. Throughout all of Star Trek, he worked harder than any other person to make sure that the integrity of the character, the show, the fans, was not wasted on bad storytelling.

Outside of Star Trek, I saw that he would not continue something that did not make him a better person and a better actor, which is part of why he left *Mission: Impossible*. On that show, he had easy work, was well paid, and had no worries. Most people would be content to stay there as long as they could, but not Leonard Nimoy. He said that he left the show because it was no longer a fulfilling experience for him. He had outgrown it, learned all he could from it.

Just those facts alone could make anybody respect Leonard Nimoy the man, but it went a bit farther with me. I'd sometimes wondered if it would be worth even trying to do what I want, especially if I don't know if I will succeed. If there were too many obstacles, I would pick a different goal. True, for someone fourteen years old and younger, my goals weren't as life-changing as they would be even for an eighteen year old, but without the influence of Leonard Nimoy on my life, I don't think I ever would have tried to plunge through difficulties. I just would have continued picking new goals if my current one seemed to hard to get to.

My admiration for him is not confined to the mere facts. I also love him for who he is. He is a man of great intelligence and wisdom, but he is always striving to better himself. He is known all over the world, but never takes any credit for it, always saying it is because of the talent of other people – a man of great humility. He is a very serious and dignified man, but knows how to laugh and smile, and enjoys making others do it too. He is a man of deep feelings, and he shares them with everybody he touches. He knows how to laugh and cry. He knows when to joke and when to be serious. He comforts when needed, and lets others comfort when he needs it. And, to me, one of the most important things about him is that he is a family man, dedicated

to his family. I've known of families who have been thrown into turmoil because one member is not dedicated, and this is one of the most important reasons for my great respect for Leonard Nimoy.

Then again, there is so much to respect and love about him, so much about him to learn from, maybe there is nothing I can just point to and say "This is the reason I love him and respect him. This is why he touched me, why he inspired me." Maybe that is all the explanation I need to give.

3

Being Human

SCOTT HIGA

We are gathered here today to pay final respects to our honored dead. And yet it should be noted, in the midst of our sorrow, this death takes place in the shadow of new life, the sunrise of a new world; a world that our beloved comrade gave his life to protect and nourish. He did not feel this sacrifice a vain or empty one, and we will not debate his profound wisdom at these proceedings. Of my friend, I can only say this: of all the souls I have encountered in my travels, his was the most… human.[2]

James T. Kirk spoke these words during his eulogy of Captain Spock.

I wasn't terribly well versed in the Star Trek universe when I first saw *The Wrath of Khan*. I hadn't watched much of the original series and I was just getting my feet wet with *The Next*

[2] Meyer, Nicholas, *Star Trek II: The Wrath of Khan*, Paramount Pictures, 1982

Generation. I wasn't aware of the gravity of Spock's death, partially because I wasn't emotionally invested in the character but also because I knew he somehow came back to life. Even then, though, I found Kirk's eulogy intriguing and I still do today.

My friends and I would argue over whether or not Kirk was tarnishing the memory of his beloved comrade. Spock never fully embraced his humanity yet that is what Kirk focused on. I don't think Kirk meant any disrespect to Spock, but my friends and I were staunch members of Team Picard and took any chance we had to throw stones at Kirk.

Describing a soul as human in the Star Trek universe is a little puzzling, though. Humanity is created in the image of God and cannot be fully understood independent of its creator. Gene Roddenberry's vision of a future built upon secular humanism leaves no room for God and, therefore, a complete understanding of what it means to be human.

Granted, we can display the best parts of humanity independent of an understanding and relationship with God. Growing up in a Christian home, I just assumed that people who weren't Christians weren't capable of love, peace, truth, justice, grace and compassion. Obviously I was mistaken. I have encountered numerous people who express those qualities far better than a lot of Christians.

But those qualities don't just spontaneously appear within humanity, like some Big Bang of the soul.

Those qualities are a reflection of the character of God. All of the love, peace, truth, justice, grace and compassion that we see in ourselves and in Spock are mere reflections of what is found in God.

We're only capable of love because God is love.

Scotty is only capable of engineering creativity because God is the ultimate creator.

Spock is only capable of sacrifice because God made the ultimate sacrifice in sending his Son to redeem the universe, even the parts where no one has gone before.

I've gotten to the point of appreciating Kirk's eulogy of Spock and what it means to be human within the Star Trek

universe. We can never fully grasp being human, though, until we embrace the one in whose image we are created.

And that's just as true now as it will be in the 23rd century. How can we better reflect God's character to the world around us?

4

Mom, Dad, and Mr. Spock

Lisa M. Lynch

How lovely that of all the characters in *Star Trek* TOS, it is Mr. Spock whose parents we really and truly get to meet. Mr. Spock – supposedly the most devoid of emotion and carrying the least amount of sentimentality. His parents, Sarek and Amanda, become a large part of Star Trek lore and are almost as famous as the main characters themselves. Even casual viewers of Star Trek are familiar with them.

Mr. Spock famously has two sides to him – he is of mixed race. The human side of him is personified in his mother Amanda, and the Vulcan side is personified (Vulcanified?) in his father Sarek. He is one being created from two very different beings, and he must reconcile his single existence from two separate parts. In this case, these two separate parts are so different, they hail from different parts of the galaxy!

Although Spock is of an alien heritage, he still experiences the same issues with his parents that we all go through. He must

decide which parent's culture he will align himself with. Though he is human and Vulcan, he calls himself "Vulcan" and chooses the trappings that go along with it. Although he is as much human as he is Vulcan, he feels he is far superior to humans, and is seen by other humans as alien.

More distressingly, however, he is seen by Vulcans as alien. As a child, he was targeted and ridiculed for his human heritage and his human mother. Being singled out and mocked forced him to contend with his human inability to control his emotions. Although one wonders, would even a pure Vulcan child be able to handle such blatant contempt? For a race that claims such adherence to logic, there is still an emotional inability to accept what is different. These peers who mocked him displayed the very human characteristics of intolerance and enough self-doubt to put someone down for the benefit of building oneself up. It's classic playground bully behavior. That's not logical, but perhaps it is universal.

So to Vulcans, Spock is human, despite his immersion in and acceptance of Vulcan culture and despite being raised on Vulcan and learning Vulcan values. And to humans Spock is Vulcan. His appearance and attitudes are strange. He's an outsider on both worlds. And when we meet him, he lives and works on an Earth space vessel, but he is flying through outer space, physically a citizen of neither planet.

As far as Spock's relationship with his parents, he experiences the same issues that we do. Spock and his father Sarek were estranged for 20 years because of Spock's decision to forgo the Vulcan Science Academy in favor of Starfleet. And Sarek experienced the emotions (indeed!) of hurt, disappointment, and even embarrassment that his son ran off to do such a human thing. He went against his father's wishes and joined a "human" organization.

In the episode "The Naked Time," Spock experiences a lack of emotional control due to a virus that infects the ship and he cries over the fact that he could never show his mother the love that she deserved. In the episode "This Side of Paradise," Kirk has to make Spock angry enough to shake him from the

influence of the flower spores of Omicron Ceti III and insulting his father does the trick.

In the second season's episode "Journey to Babel," Sarek boards the *Enterprise* for a diplomatic mission along with his wife, and when they meet up with Spock for the first time in years, there is no acknowledgment between them. But in fairly short order, as Sarek realizes Spock's level of importance, he begins to respect his position and so begins the softening of their relationship. When Sarek falls ill with heart trouble, Dr. McCoy can perform a complicated surgery, but only with Spock's help. A risky blood transfusion from Spock to Sarek is needed save him. Sarek has a very rare blood type that very few Vulcans posses, and Spock shares that blood type.

At first Spock is willing to undergo the transfusion to save his father. But when Kirk is injured and unable to captain the ship during a volatile moment, Spock decides against the transfusion because he must lead the ship. He argues with his mother Amanda that his own father would think it illogical to try and save only him when the lives of the entire crew are in jeopardy. This jives perfectly with Spock's later assertion that the needs of the many outweigh the needs of the few, or the one, in the 1982 movie *The Wrath of Khan*. Amanda's desperate answer to Spock's cold logic in his refusal to help his father at this crucial moment: "There must be a part of me in you." In fact there is. It's clear even when they are talking about saving Sarek versus protecting the crew against danger. He is emotional and his face and voice betray the pain he feels in causing his mother such anguish. Upon his final refusal to help, she slaps him—hard— and leaves. He walks up to the door she had just stormed out of and places his hand there, heartbroken.

When Kirk learns that Spock has chosen to be loyal to the *Enterprise*, but to his father's determent, he fools Spock into thinking he is well enough to captain the ship. So, Spock makes the decision to help his father.

Amanda and Sarek left such an impression on the creators and viewers of Star Trek that they show up again in the Trek films. In 1984's *The Search for Spock*, Sarek, clearly grieving for the loss of his son, goes to Kirk thinking the captain

holds Spock's *katra,* or his spirit. He insists Kirk deliver it home to Vulcan. Sarek experiences some panic when he learns that Kirk is in fact not holding the katra.

In the 1986 film *The Voyage Home*, Spock is on Vulcan after having his katra (thanks to the unwitting carrier Dr. McCoy) put back in his renewed body. He has to relearn everything as only his soul has been replaced, not his education. A computer teaches him what he needs to know, and upon quizzing him, asks "How do you feel?" That certainly confuses Spock. We find out Amanda was the one who had set up the learning program, and she placed that question in because she wanted him to be more accepting of his humanity. Apparently, she felt she had a second chance to help him find that part of her in him!

At the end of that film, while on Earth, Spock is talking with his father. Sarek asks if Spock has any messages for his mother. Spock tells Sarek , "Tell her…I *feel* fine."

In *Star Trek: The Next Generation's* episode "Sarek," Sarek is shown falling prey to a disease which causes him to lose control of his emotions. Captain Picard temporarily holds Sarek's mental turmoil via mind meld so Sarek can take Picard's calm rationality and complete an important job as Ambassador. Picard crumbles emotionally under the weight of Sarek's pain and regret over his relationship with his late wife Amanda and his son Spock.

In the TNG episode "Unification Part 2," after Sarek's death, Picard allows Spock to mind meld with him to access Sarek's thoughts, since Spock and Sarek never engaged in a mind meld. It is implied that this was due to their continued strained relationship. Spock then learns then of Sarek's love for him and his face registers deep emotion.

As Spock matures in the *Star Trek* films, he begins to reconcile his two disparate natures, becoming more willing to embrace his human side. As is often true for anybody, age and experience create a greater self-acceptance, and Spock's relationship with his parents helped him evolve in that manner.

Isn't that true for us too?

5

St. Spock of Vulcan, Patron Saint of Star Trek

KEVIN C. NEECE

Spock is not just Star Trek's most popular character; he is at its very core. Spock has been with Star Trek from the very beginning. He is the only character from the original, rejected pilot "The Cage" to continue as a series regular. Spock has been Star Trek's wisdom, its conscience, its moral core. Because of that, Leonard Nimoy, the actor who portrayed him for Star Trek's first 45 years, has been the same.

But what's sacred about Spock? To be sacred means to be set apart, dedicated, consecrated. It can mean dedication to God or to a particular purpose. In Spock, we see a character who is set apart in many ways.

As both Lisa M. Lynch and T'Nara Valdrin Kelensa have noted in their Spocktober guest posts, Spock is a citizen of two cultures. In both cultures, however, he is different – unique, but also alone. His dedication to Vulcan principles makes him an outsider among humans because he rejects their way of life, but

also, oddly enough, among Vulcans as well because he is half human.

In this way, he reflects the Biblical prophecy regarding Jesus: "He was despised and rejected by people, one who experienced pain and was acquainted with illness; people hid their faces from him; he was despised, and we considered him insignificant." (Isaiah 53:3, NET)

Rejection seems an odd way to come by holiness, but it's one that the Scriptures continually refer to. As Jesus himself said, "I tell you the truth, no prophet is acceptable in his hometown." (Luke 4:24, NET) But Spock also sets himself apart.

Though he had the opportunity to continue his family's tradition and complete his studies at the Vulcan Science Academy, Spock chose instead to join Starfleet. Similarly, he left Starfleet to return to Vulcan and complete the kolinahr ritual, which would rid him of all emotions. However, he later rejected this plan and returned to Starfleet.

In each of these three decisions, we see Spock seeking his true self by separating himself off from others. Jesus behaved similarly, isolating himself in the desert before he began his ministry, across a sea after the death of John the Baptist and away from his disciples in the Garden of Gethsemane before his crucifixion.

Each of these moments of separation seem to represent Jesus' desire to re-center himself, to seek the right path and to prepare for great changes in his life. He sought purity in the desert in preparation for his ministry, sought solace during a time of grief when the man he admired most was killed and begged his Father for another answer when he was called to sacrifice his life.

Spock left Vulcan for Starfleet to live apart from both Earth and Vulcan, two planets that could not be his home. He sought purity in the desert through kolinahr, but realized that this was a temptation toward an easier life – much like the desert temptation Jesus faced to give in to disordered human desires.

When he again left Vulcan to accompany Kirk and his old *Enterprise* comrades during the V'Ger incident, Spock remained somewhat distant and isolated, ultimately venturing

out into space alone and carrying his personal quest deep into the heart of V'Ger. In this way, he separated himself from Vulcan and also from his friends (as Christ did in Gethsemane) in a quest for balance in his life, which he found.

Spock is also dedicated. Whether loyal by duty to Starfleet, by upbringing to Logic or (whether he admits it or not) by love to his friends, Spock is a devotee.

Given that the Star Trek universe is supposed to be a place where religion has passed away from human experience, it seems to me that it is not insignificant that its central character is also its most religious. From "Amok Time" onward, the ritualistic and spiritual nature of Vulcan culture takes a larger and larger role in the development of Spock's character.

With his strange powers like the Vulcan mind meld and nerve pinch, his quiet calm and cool reserve, Spock seems in touch with something otherworldly and ethereal. His bowl-like haircut mimics that of a Catholic monk and from *Star Trek: The Motion Picture* onward, we frequently see him in ceremonial robes and engaged in deep meditation.

Spock is, in essence, a monk. He seeks wisdom, solitude and spiritual purity. His race is a deeply spiritual one that recognizes the essence in themselves – their katra or soul – as their truest being. His quest for Logic and a higher Vulcan existence leads him also to a higher humanity, as he ultimately shows the greatest love humans are capable of by sacrificing himself for his friends. (John 15:13)

But Spock's spiritual significance goes even deeper and I'll be sharing more about it in my next piece.

6

St. Spock of Vulcan, First Christ Figure of Star Trek

Kevin C. Neece

 I wrote previously on Spock's sacred and spiritual nature. But there's more to him than being the Patron Saint of Star Trek. He's also one of the series' Christ figures. The symbolism is surprisingly deep (if unintentional), but I'll hit the high points here.

 To be clear, a Christ figure is any character in fiction who represents Christ in some way, either in whole or in part. Usually this is an intentional parallel but, as with much of what we're discussing at UCP, sometimes we can find characters that reflect Christ whether they are specifically meant to do so or not.

The most common feature that makes a character a Christ figure is martyrdom.[3] This is the most obvious way in which Spock fits the bill, giving his life for the crew of the *Enterprise* in *Star Trek II: The Wrath of Khan*. This act alone would put Spock in the Christ figure ballpark, but a more complete Christ figure will also rise from the dead. Of course, Spock's resurrection takes place in *Star Trek III: The Search for Spock*.

That's all well and good, but Spock's parallels with Christ don't end at merely dying and rising again. Certain aspects of his character, along with the deeper significance of his sacrifice, both reinforce the metaphor.

First, Spock has a dual nature. Christ is described in Scripture as both human and Divine. In the same way, Spock is both human and Vulcan. Further, his Vulcan half is associated with a devoted, spiritual and elevated existence that may be seen as superhuman and therefore symbolically Divine. This is especially true, considering Vulcans' greater physical strength, mental capacity, endurance and longevity. Jesus was born of a human woman, but his father is Yahweh. Similarly, Spock's dual nature is represented by his parentage – his Vulcan (superhuman) father, Sarek, and his human mother, Amanda. Spock struggles with balancing this duality, just as Jesus did.

As I mentioned in my previous post, Spock is a deeply spiritual character who is a part of a ritualistic, religious culture. This reflects Jesus' Jewish faith and culture, especially since Leonard Nimoy himself is Jewish and drew on his faith traditions to help shape Vulcan rituals. Spock is deeply invested in his Vulcan education and, just as Jesus impressed the elders at the temple in Jerusalem, shows much promise in the Vulcan Science Academy.

[3] Usually, this feature is essential, as there are many characteristics Jesus shares with a number of other iconic figures. For example, Surak, the Vulcan patriarch of Logic, shares many traits with Christ and could even be called the savior of the Vulcan race. However, as the bringer of the law who did was not martyred and in the context of the Jewishness of Vulcan culture, he is much more aptly described as a Moses figure.

But Spock does not find his calling at the Science Academy, nor did Jesus find his within the temple walls. The 2009 film *Star Trek* takes this moment in Spock's life further, showing his rejection of the Science Academy council's ways as he refuses to enter the institution because he judges them to be unjust in much the way that Jesus clashed with religious authorities in Jerusalem. Both Spock and Jesus, therefore, find themselves at odds with the gatekeepers of their culture's central institutions, even as they devote themselves to the values and teachings those institutions are meant to uphold.

Still, it is at the point of sacrifice that Spock bears his greatest resemblance to Christ and it is this moment that causes us to look for greater Christological significance in the character. As I mentioned, though, the significance of this element goes beyond death and resurrection. It's one thing to die, even as a martyr for a cause, but Spock's death reflects Christ's on much more than superficial levels.

First, no one kills Spock. He chooses to act in a manner that brings about his own death. Even though Jesus was executed, he still placed himself in a position that would guarantee his crucifixion. As he said, "No one takes [my life] away from me, but I lay it down of my own free will." (John 10:17-18)

Spock's sacrifice is certainly an act of salvation for the *Enterprise* crew, giving the ship just enough time to escape the Genesis wave. But the intent behind Khan's attack is of a more personal nature and it is a personal redemption that Spock accomplishes. Khan comes from Kirk's past seeking retribution for past sins, representing the determined reach and unrelenting grasp of damnation. "From Hell's heart," Khann says, "I stab at thee." Khan represents the consequences, deserved or otherwise, of Kirk's actions. He is Kirk's judge and intends to be his executioner.

Throughout the film, the theme of age and death is prevalent, with a particular focus on Kirk growing older. Through the Genesis cave scene, youth is connected with Edenic imagery and associated with restoration. After Spock's funeral, watching the sun rise on a garden-like new world called Genesis,

Kirk says that he feels "young." At this moment, Spock's death has restored Kirk to a state of renewed life that is associated with Eden, a state from which Kirk had previously fallen. Moreover, Spock has died in Kirk's place and so has delivered him from the consequences of his sin. In this way, his death is not just martyrdom, but substitutionary atonement.

Add to this that the crew of the *Enterprise* – and more specifically, her captain – is consistently symbolic of the human race in Star Trek, even to the point of the captain frequently being singled out as humankind's representative, and Spock could be said to symbolically atone for the sins of all humanity. With this in mind, it seems no wonder, then, that the music at Spock's funeral and in the accompanying the score is "Amazing Grace."

So the image of Christ Spock represents is one who is of a dual nature from one human and one superhuman parent who finds himself at odds with the leadership of the core institutions of his ritualistic, religious culture. His is a deeply spiritual, meditative Christ figure who sets himself apart and willingly sacrifices his life for others, dying in their place to deliver them from the consequences of their sin and restore them to a state unmarred by age and death. And ultimately, he rises again, his tomb open and his grave clothes left behind.

Again, I'm not sure any of this is at all intentional. If it were, that intention would certainly not have come from Gene Roddenberry. But Spock's status as a Christ figure is one area where I see what might be a kind of "Christ-haunting" in Star Trek. Somehow, despite (or perhaps because of) its efforts to move past religion, the series constantly bumps up against the Gospel. So, the fact that Spock is a Christ figure seems…only logical.

2012

7

Spock, the Light of the Romulans

Mickey Haist, Jr.

Star Trek started with the original series playing on VHS. This was the version of Trek that my dad loved, and it was how I came to know the world of aliens and space ships. But the old show was never really 'mine.' It belonged to my dad. He was the one that found it first, when he was a teenager, and he was the one that brought the tapes home or set the VCR to record the reruns that played in the middle of the night.

I finally felt like I owned Star Trek with *The Next Generation*. Now, I was still pretty young when that was playing the first time. So my memories of it are mostly from one magical summer. One of my older sisters was home from college for the summer. She brought her TV with her. And the only space in the house to store this TV was in the room I shared with my little brother.

Reruns of *Star Trek: The Next Generation*, the version that my dad didn't like, played every night at eleven. My twelve-year-

old self battled exhaustion from a full day's game of ball tag to watch. My little brother usually managed to catch the "Space…the final frontier" monologue before he drifted off to sleep.

There were two nights that summer that summoned my dad up to the boys' room for some late-night Star Trek. What two-part story could have possibly bridged the two generations? It wasn't the Borg or the Klingon double-length episodes that inspired the unity. This unification could only have been brought about by Spock.

Spock is the great bridging character. Behind the scenes, he unites generations; both the original pilot episode and the regular series that followed and he then bridged the Original Series with the Next Generation.

Inside the narrative world of Trek, Spock represents two worlds. He is half human and half Vulcan. He is a member of both worlds, having proven himself with both the Vulcan Science Council and the Earth-based Starfleet Academy. Spock is not halves of a human and halves of a Vulcan. By his work and accomplishments, he is fully Vulcan. And he is fully human. At least, he could pass as a full member of either species if he chose.

Spock is the great bridge between worlds. He straddles the Vulcan and human worlds in the context of the story.

Spock's role as unifier forms the basis of this wonderful two-part story. In this case, he's pursuing the Romulans, those distant cousins to the Vulcans. The violent and emotionally motivated brothers of the arched eyebrows have been functioning as their own race for as long anyone has known.

The Great Unifier in the Sky

As unifier of generations of Trek fans, and as unifier of aliens and humans, Spock's position resembles that of the Great Unifier: Jesus Christ. Through Christ, generations are brought to one place, equal to each other. Precedence and seniority have nothing to do with placement in Christ's Kingdom. "He who wants to be first shall be last" etc. As the intermediary for aliens and humans, Spock again demonstrates a shared function with Christ.

Spock stands between humans and Vulcans, equal parts both, yet fully both. He is not less human or less Vulcan. Certainly to Vulcans, he appears quite human and likewise to humans would he appear more Vulcan. But he is both. A fully confirmed applicant to the Vulcan Science Council, he could live out his days fully Vulcan. Spock could just as legally live his life as a full member of earth human society. He is both. And he lived that way, expressing both in a way that defied compartmentalization yet announced allegiance to both.

In both roles he expressed the opposing racial heritage. That is, to humans he appeared to be extremely Vulcan and to Vulcans he appeared extremely human. This echoes a bit of Christ's dilemma. To humans, Christ appears totally other-worldly. His refusal to sin confounds us and clearly sets Him apart from the rest of us. And to the religious people, He appears to be a little too human.

Those that would identify themselves as human value Christ's/Spock's alien-ness and those that would identify themselves as religious/Vulcan condemn Christ/Spock for an apparent abundance of human attributes.

The Imago Vulcanis

Like Christ, Spock is willing to sacrifice his own life for the restoration of those who possess his image but have set themselves against him.

Spotted by Starfleet Command deep within Romulan territory, Spock is pursued by Picard and Data. When they eventually find him, they still assume that he was captured. The major shock, even for the discerning viewer who read the title of the episode, is the cause of Spock's surprising presence on Romulus: he's there on a mission to reconcile the two species.

Vulcans and Romulans have a common history. One path was carved because of a desire for emotional control. The other path by a desire for emotional expression. As a result, their cultures are different. Their values are different. Their very appearances have even changed.

Yet Spock knows of their common history.

The Romulans are unwilling to accept Spock's offer. Resistant to the end, the Romulans serve as an excellent illustration for fallen humans. When Christ finally came, He was not greeted as a hero. He was mocked and betrayed before being arrested and executed. The hero of the world, come to reconcile His image-bearers that had fallen away, was rejected and killed by those He aimed to commune with.

Spock's dilemma is startlingly similar. He is even betrayed by a member of his inner circle. Pardek (played by Malachi Throne, who provided the voice of a Talosian in *The Cage*, which was Nimoy's first appearance as Spock) is Judas to Spock's Christ.

Walking Through Walls

Once betrayed, Spock and his friends from the Enterprise D are taken prisoner by Sela, a weird half-sister or something of Tasha Yar. Unwilling to cooperate with her scheme to keep Vulcans and Romulans antagonistic toward one another, Spock is locked up, assumed to be completely hindered.

Sela plans to use a holographic Spock to make a speech which will ruin any hope of Vulcan/Romulan reunification. Sela leaves her office for a moment and returns to find Riker and two other Starfleet guys in the place she had Spock, Picard, and Data locked up. She fires on them, but her phaser beam passes through them. They were only holograms. While she is disoriented, Spock emerges through the wall (another hologram) and puts an end to Sela's plans.

Just when he was believed to be dealt with, right at the moment the enemy believed Spock was never going to raise any more problems; he walks through the wall, revealing that he was in possession of a power greater than anything she believed before.

Just when He was believed to be dead, right at the moment the enemy believed Jesus was never going to raise any more problems; He walks through the wall, revealing that He was in possession of a power greater than anything believed about Him before.

Christ rose again. Spock did so symbolically, by emerging from the false wall.

The Vigilante Factor

The methods needed to begin reunification of the Romulans and Vulcans required a guerilla approach to diplomacy. Typical avenues would not work, especially not for a figure as famous as Ambassador Spock. Christ's own work to reunite His rebellious creation with Himself was done so without permission by the religious authorities of the time. Spock disregarded the rules and appealed to a higher rule, a moral rule. Jesus Christ appealed to a rule even higher than a moral rule. He appealed to His own authority over both Heaven and Earth when He disregarded the authority of the religious leadership of the time.

The Love of the Father

Christ's last words, before succumbing to the tortuous death of crucifixion, were, "My god, my god. Why have you forsaken Me?"

Of the whole Biblical narrative, from fratricide to genocide to adultery and child sacrifice, this is the moment, in all of Scripture, that chills me the most. How could Jesus Christ be removed from the Godhead? How could He suffer the pains of hell? After suffering what we might of small minds might consider the most painful experiences possible, He was then isolated from the perfect community He has always known.

There is no relief that comes from the sudden silence. Neither was there any peace in the success of His mission. A separation that lasts two days is a full separation. Absence may make the heart grow fonder but an increase in fondness does not summon the person being missed. Whether gone for an hour, a weekend, or forever, the person is gone. And every moment of that separation is comprised of actual time of complete absence. Christ was dead.

Being forsaken may seem like no big deal if you hate god. I mean, I don't mind not being present with that bully from freshman year of high school. Why should I mind being absent

from another character I would describe with similarly defiant terms?

Separation from god – the Real God – is not simply absence from His character. It is absence from the Him in you. Remember, Spock's motivation for reconciling the Romulans and Vulcans is rooted in a shared image. Whether one admits or denies it, we are all made in God's image. The God that built the universe formed us in His image. Our sin has tarnished it. Our rebellion has corrupted it. But the image of God is not fragile to human hands. Only God can endow, or remove it.

Separation from God, the kind of forsaking that Jesus suffered and the kind that faces all who reject the reunification announced by Christ, is the removal of the image of God.

When the God-given attributes are removed from a person, there isn't much left to a person. I imagine God asking if we used our hands to meet Him. If we did not, then He reclaims them. He asks if we used our minds to learn more about Him. Again, if we did not, then He reclaims them. And He continues to inquire about the rest of our being. Our bodies, our imaginations, our feet, our eyes. These pieces of a person were granted by a god eager for His creation to meet Him. And when these pieces are used for purposes that are exactly against the (re)unification of Creator and creation, He is fully justified in reclaiming them.

And so we all answer that we haven't used ourselves to learn about Him, or to meet Him, or to tell about Him. Christ steps in between for some, announcing that His work of reunification was applied to this life. "This person appears at first to be deserving of the dreaded separation, but was made holy by the work I accomplished in my exile."

Imagine being stripped of everything God gave you. What would be left? Well, the only thing left would be whatever you brought to the party. And what exactly is that? Just a grumble, as CS Lewis called it. You didn't bring your mind or your feet or anything of your image. God gave you an image, basing it on Himself. You grumbled. That's all you or I did.

So when Christ was forsaken, what was left for Him? He didn't even grumble. So what was left for Him? He had no mind or body.

The grumbles of a thousand future saints echoed in His ears. "It is finished. My god. My god. Why have you forsaken Me?" Next sound in His ears – scratch that, He doesn't even have ears – next sound in His … existence (?) is the vile rage of His not-yet-regenerate Christians.

Jesus Christ died so that we might not be forsaken. He was forsaken, left alone with our rage against God, so that we could continue existing in God's image. God's image is taken away from those who hate Him continually. The image is maintained, and restored, in those who repent of their anger against God and accept that Christ suffered isolation on their behalf.

Christ died the death I deserve. He was restored to life and community with the Father where I deserve isolation.

I mention all this because the end of this episode illustrates the isolation and reunion that I find so precious. Sarek and Spock were at odds for years. Imagine Sarek is God the Father, and Spock is the sinner. Separated for years, Spock thinks his father harbors only resentment and disappointment for him. He meets a messenger, one that knows his father's will in a deep way.
Picard has touched the mind of Sarek. And he descends into the place of Spock to deliver this message. Picard and Sarek are one, and Picard and Spock must become one so that Spock and Sarek can become one.

The message the father has for his son is so obvious. Spock has been repeating it for years, over a century. What his father has for him is something he should have known all along.
What do you think the message the Father in Heaven has for you? If you could meet an Ambassador of God (which you can do easily enough), what would His message be?

I don't think it would be anything too surprising. It will probably be refreshing. It will probably encourage you and it should even restore you. But I doubt the words would be anything you hadn't heard before.

For Spock, the simple message from his father was, "Live long and prosper."

He says that all the time. But when its source is identified, his whole world changes. He sees that his father loves him.

For you, the message is probably equally familiar. You may even say variations of it on a daily basis. "God loves you," or, "God bless you."

Knowing that the Creator of the universe has that message for you, how might your views of yourself and of God change? From my experience, I discovered a peace deeper than any I had known before. I had a peace about why I cared about things like love and reconciliation and image. I cared about them because the image of God that was in me cared about them!

Being restored to the Father is the ultimate peace. I recommend using the parts He gave you to explore the possibilities of unification.

8

The Wisdom of Spock: 10 Life Lessons from Everyone's Favorite Vulcan

Neil Shurley[4]

The writing instructor told us to choose a Wisdom Figure to write about. I had to wrap my head around the term for a moment. Who is a wisdom figure to me? I figured I should list Moses or Jesus or one of those bible guys. My high school drama teacher definitely inspired me. But wisdom figure? The whole concept sort of stumped me.

And then I had a revelation. The only logical candidate popped into my head.

Spock.

[4] This piece was previously published on Neil's blog at http://www.examiner.com/article/the-wisdom-of-spock-10-life-lessons-from-everyone-s-favorite-vulcan and is reprinted by permission.

Yes, he's got pointy ears. Yes, he's from another planet. Yes, he lacks emotions. Yes, he's fictional. But Spock is there, in my memory, in my views of the world, in the views of my own life. He stands there erect, hands clasped behind his back in an "at ease" position that I still mimic to this day.

He's loyal. Rational. Yes, I have to say it, he's logical. He appreciates the scientific method. And while he maintains a cool reserve, we all know that underneath he's got a seething cauldron of raw feelings boiling away, kept under control by a single upturned eyebrow. Puzzles are a challenge, a way to learn. And he usually handles conflict with a Zen-like detachment.

He's a stranger amidst a crew of irrational humans, trying to understand the foreign language of emotional responses. For a kid who kept moving to new houses, new cities, new friends, why not rely on someone constant, someone whose judgment you could trust, who would loyally appear in your living room weekday afternoons at 4.

Spock as Wisdom Figure. Why not?

1. Greetings and felicitations!

What could be a better greeting than Live Long and Prosper? It's the first indication that the renowned Vulcan "logic" is not just lifeless and computational. It's a philosophy of rationality, yes, but also of radical empathy. And it's a blessing. Famously, Leonard Nimoy based the salute on a gesture he once saw a Rabbi perform.

2. Vive le Difference.

Vulcans celebrate diversity. The IDIC symbol – perhaps created cynically by Gene Roddenberry as a way to sell jewelry – represents Infinite Diversity in Infinite Combinations. It's a cornerstone of Vulcan philosophy and it makes sense. It's logical to understand that the universe derives power from the diversity of its natural phenomena and its differing cultures.

Diversity invites democracy. Diversity is expansive, it invites the embrace of exploration, of change, of growth. It shows that the Logic Vulcans practice is not cold and computational. It

affirms life and peace as well as the triumph of intelligence over force.

3. Ape shall not kill ape (to quote another franchise).
Spock says many times that it's illogical to kill without reason. That's why he's a vegetarian, why he'd rather nerve pinch one of his enemies than phaser him out of existence. Spock is part-human, and we can sense that even though he suppresses his emotions, even though he might deny it, he still feels compassion, still feels empathy.

4. We reach!
Remember the space hippies? Spock found common ground with them in their concept of One. "One is the Beginning." They sought peace, you know, like hippies everywhere, and Spock knew of their ideas, maybe even respected them. He reached out to the hippies in a way that the establishment—Captain Kirk—never could.

5. Freebird!
He even jammed with the space hippies. Because Spock digs music. He plays an instrument – the Vulcan harp. Yes, the arts are important to the logical, unemotional Vulcans. And that makes sense. Music can help us reach places that words can't always touch. It delves deep into our, yes, emotions, and moves us in distinctly un-rational ways.

6. The inner light
And why not dive into our own depths? After all, Spock practices meditation. He contemplates the divide between self and the world, keeps himself in balance between the emotions he feels and the world in which he exists. Contrary to popular belief, Vulcans have emotions; they just keep them under control.

7. It's all about balance
Spock learned the value of feelings. As you watch the character grow from the original series to the movies, you can see the change. In the first movie he learned that a machine cannot

experience the joy of touch, of physically connecting with others. And that experience changed him. Spock learns. He grows. He became comfortable with the balance between his emotional human half and his rational Vulcan self.

By the time of the latest movie, Spock has mellowed significantly. He's literally a wise old man, a sage who's extremely comfortable in his own ears, so much so that, if you watch closely, he pretty nearly smiles at the end of the film. And I am talking about Leonard Nimoy Spock, not young sexy Spock.

8. Stay in school, kids

He's a cheerleader for science. The scientific method is simply the best tool we've yet devised to understand our surroundings. Careful experimentation, reason, making choices based on evidence rather than instinct or intuition. Why embrace mumbo jumbo when the wonders of the infinite universe are open to us through science? Emotions have their place, but reason and evidence usually bring us to the best conclusion.

9. Actual wisdom

The philosophy that sums up Spock's experience? The needs of the many outweigh the needs of the few. You have to apply this idea on a case-by-case basis, of course, and that's where logic fits in. If killing one person would save a million people from a nasty headache, do the needs of the many still outweigh the needs of the one? Probably not. But it's worth spending time thinking about how your own personal needs conflict with the needs of the many - and whether there are instances where you might be able to put others' needs first.

And isn't that the point underlying many of our earth-based philosophies? Some guy named Jesus said lots of stuff about subverting your own needs, your own desires, about giving away what you have and serving others. Spock serves others by operating as a vessel for science. He's your first officer, your trusted advisor. Your friend. He's got your back.

10. He's Cool

Sure, Kirk got the girls. And that's certainly an appealing trait to emulate. But the girls WANTED Spock. Spock was cool. And he truly understood -- if not himself, at least the world - the universe - around him. And isn't that something we'd all like? Wouldn't we all be better off if we tried to observe and understand one another? Maybe it's not logical, but it's fascinating to consider.

Research sources include the following.
- *Charlie Jane Anders' excellent "How You Can Live Like A Vulcan Without Bleeding Green" from io9.com*[5]
- *I Am Not Spock by Leonard Nimoy*

[5] http://Io9.com/5523773/how-you-can-live-like-a-vulcan-without-bleeding-green

9

True Confessions of a Gen-X Trekkie

SHANNA GILKESON

As Star Trek nears its 50th anniversary, we all know by now that fandom in general – and Star Trek in particular – attracts those of us who've felt different from everyone else, who've been marginalized by the various communities to which we belong, who feel like outsiders in our own towns, our own schools, and even our own homes at times. Through the '70s and '80s, we heard the familiar stories told at conventions and written in books by insiders and Big Name Fans. For many of us, Star Trek may very well be our first experience with feeling like somebody out there "gets" us, that somebody out there was listening and understands who we are and what we need.

Spock himself has been a rallying point for those of us who aren't like everybody else. Half human and half Vulcan, Spock doesn't quite fit into one world or the other, so he's had a pretty hard time of it himself. Even in Starfleet, he's occasionally the victim of bigotry and prejudice, but eventually he makes the

friends who matter, wins his father's approval, and carves out a pretty awesome career for himself doing what he's passionate about: exploration and the pursuit of knowledge and peace. Spock shows us that he's made peace with his place in the world, and that we can too.

This was something I understood at a fairly young age, though I didn't have the words to articulate it until much later. My home life was great; I was surrounded by a family who loved me and I felt pretty secure. I had no siblings, though, and there were never any kids around, so when it came time to go to school, I had a hard time relating to my peers. I was an easy target for getting picked on and, I dare say, outright bullied. Factor in that small towns aren't always the best places to have your own way of thinking and your own way of doing things. I was also growing up the '70s and '80s. It was not yet fashionable for girls to like sci-fi or action/adventure, and boys didn't want to have much to do with girls because they were, well, *icky*. I was usually too ashamed and embarrassed to tell my family what went on at school, and thus began my vague feelings of alienation at home. It wasn't their fault; they couldn't help me fix what I wouldn't talk about. As a result, the *U.S.S. Enterprise* was the only place I could "go" where it was okay to be myself. Someone like Spock would understand.

Any of this sounding familiar yet? If not, you might've come along later on, when Star Trek became more mainstreamed and gender expectations weren't quite as inflexible. Mine was the first generation that was told it was okay for girls to play with trucks and boys to play with dolls, but as with all social change, it takes a while before it's *really* "okay" in most people's minds. No wonder there's probably a whole generation of Trekkies out there who wanted to be just like Spock when they grew up.

Though Spock was my role model, it didn't change the fact that I was a human girl who wasn't raised in a society in which logic was prized over emotion. This became all too obvious by the time I hit middle school. I was thirteen in 1983, and no closer to being accepted by my peers. I was the funny-looking freak who wasn't allowed to wear makeup at school yet and who liked all that weird stuff. Girls were putting pictures of Simon LeBon

and David Lee Roth in their lockers; I made my own statement by putting Mr. Spock in mine. I even added a shiny foil heart because I knew it would confuse and anger the masses – not very Spock-like, but since when was Spock ever a thirteen-year-old girl? At any rate, the joke was on everyone else, and I was laughing my passive-aggressive butt off.

What did I get for my trouble? My locker was broken into and my picture ripped to shreds. I still can't tell you which was more heartbreaking: the violation of my personal space, or the evidence that someone really did hate me that much for being different.

Despite it all, my admiration for Spock stayed strong. Everything canon and fanon up to that point had told us that in his youth, his peers had written him off as a freak. If Vulcan kids had school lockers, I was willing to bet his had been broken into as well and that something meaningful to him had probably been destroyed.

Thirteen is a difficult age. You want to fit in, but you want to leave your own mark on the world, too. Add the hormones of changing bodies that make us confused, obnoxious and awkward. Shake well. I was too young to escape, but I was finally old enough to reach out beyond my environment. I spent my babysitting money on *Starlog* magazines for the purpose of immersing myself deeper into Star Trek. I saw columns written by smart, talented writers, artwork submitted by fans and more importantly, published letters to the magazine from people just like me. Even better, their addresses were printed; for the first time, I could reach out to like-minded people. Some of you younger fans are probably in shock. No, you couldn't print someone's full name and address in a nationally-distributed magazine these days. You have to remember that this was the Dark Ages before Internet access. I couldn't just open up Google, type "Star Trek," and be blown away by thousands of matches directing me to various websites, fan communities, and conventions. Back then, I had to connect to people the hard way.

I had lots of pen pals by high school. Most of them were older than me – no surprise there, given my difficulties relating to people my own age. Those who weren't older were just like me:

rejected, wounded, and wishing they had someone to speak geek with at the lunch table at school. Those girls had a thing for Spock, too. All had a common thread: "Star Trek gets me. Spock gets me." Eventually, I became secure in the friendships I had and I formed more of the kind that matter. I'm back in college at 42 and I'm on my way into a wonderful career in teaching, writing, and television. I'm surrounded by smart, fabulous people. Most of them like Star Trek as much as I do.

The point is, while none of us is equipped to be like Spock, we can still follow his example. Through patience and self-acceptance, Spock turned out alright. So did I. It's been a rough road sometimes, but right now, it's a pretty awesome life.

What saddens and disturbs me is the fact that, despite living in this age of quick and easy connectivity, there are still kids out there feeling thrown away and rejected by peers and families who don't understand them. The tools that should be helping them seek solace in the company of like-minded others are often turned against them as instruments of torture. I used to be able to go home, shut my bedroom door and have a little bubble of safety as I wrote letters about Star Trek to friends. Now, because of the personal computer and the smartphone, even those spaces are no longer the sanctuaries they should be. The teasing and the bullying can follow anyone anywhere. Children commit suicide because they never get a break from the ridicule over being different.

Perhaps this generation is too far removed from the Spock I grew up with. Young people are becoming acquainted with the J.J. Abrams version of the characters that gave me something to believe in. It's my hope that future films in the franchise bring fans not only the names and the aesthetic of the original *Star Trek*, but also the philosophies behind it that helped so many of us hold it together through the loneliest parts of our lives. The original magic of *Star Trek* – the original magic of Spock – wasn't in the starships and the aliens. It was in the ideal that differences were meant to be celebrated, that the only way we'll ever get anywhere is through cooperation and acceptance. "Infinite Diversity in Infinite Combinations" isn't just a Vulcan axiom that sounds cool; for fans in the '60s, '70s, and '80s, it was our moral

compass. Star Trek didn't patronize us by telling us that our race, religion, size, or other attributes don't matter. They *do* matter, because they are what makes each of us special and different, and often through Spock, Star Trek acknowledged that.

Happy Spocktober, everyone. Live Long and Prosper.

10

In Defense of "Spock's Brain"

MATTHEW WEFLEN

When Kevin asked me if I'd like to contribute to his Spocktober series of posts, I thought about what I could add to the torrent of ink spilled over the Spock character these past 4-plus decades. Should I talk about Vulcan philosophy? Too much work with a baby at home. Vulcan mating rituals? Too many conflicting versions. Spock's out of character mind-rape of Valeris in *Star Trek VI*? Too… eww.

But then it hit me – Spock is a titular player in what many people consider the worst episode in franchise history – "Spock's Brain."

My thesis shall be this: I'm not claiming that "Spock's Brain" is a great episode. Not even a pretty good one. In fact, it's got serious problems that should not be sugarcoated. But I can think of a good ten or maybe even twenty episodes from throughout the franchise that are in fact worse. And to prove it,

I'll defend some of this episode's better points, and try to place its sins in the context of worse ones.

First of all, why don't you watch the episode, and maybe even listen to our podcast over on Treknobabble?[6] Here are some of the highlights of the episode.

First off, you have to give props to De Kelly. His line readings, and his physical acting, are really enjoyable. The eyebrow arches, and he delivers the line, "His brain is gone." The way he portrayed the Teacher machine's brain dump into him, and the slow forgetting of the advanced surgical techniques, was really good.

There are some nice scenes between the friendship triad. Kirk's steely determination to restore Spock, despite the astronomical odds and McCoy's grudging feelings of missing and loss, were moving.

And lest you think that the only highlights in this show were of the touchy-feely, fan-service, character development variety, let's talk about the science fiction. It is a strong sci-fi idea, any way you slice it, having a civilization burrow underground to survive an ice age. It considers the effects of climate change on a civilized world, and it posits some interesting wrinkles, such as a computerized repository of information to prevent a mass loss of knowledge, and a gendered division of labor (and come on, you can't deny the puerile adolescent fun of a planet full of ditzy miniskirt babes who are hungry for male contact). There is also a nice ethical conflict, between the needs of many vs. those of the few, and Spock takes the side of the many, consistent with his characterization in several previous shows, and several future films.

Effects-wise, there were a bundle of great practical shots of actors in front of viewscreen, both showing the starfield as well as the planetary diagram. I love the way the blue border around the viewscreen looked, and they really made the bridge feel like a real space by showing people interacting with the viewscreen.

[6] http://www.treknobabble.net/2010/06/original-series-season-3-spocks-brain.html

These shots actually trump many in *TNG* for creating a real sense of space.

Speaking of the schematic of the Sigma Draconis system, this effect played perfectly into a great scene – the crew debating and deducing where the space ship must have gone, each offering their own theories and justifications, based on climate and technological level. It really establishes characters like Chekov, Uhura, and Sulu as intelligent professionals, even though Kirk characteristically goes with his hunch. I also love the use of the word sapient instead of sentient – this episode got the terms right!

Also, this episode has the hot glowing phaser rock trick. I love that.

I am not going to deny that there are low points, and some of them are very low indeed.

The dialogue, though fun for its cheese factor, sometimes went beyond the pale. "In this whole galaxy, where are you going to look for Spock's brain?" Yeah. Also, the immortal "Brain and brain! What is brain?!" The 24 hour time limit is arbitrary and stupid, and typical of some of the lazier plotting devices in the franchise (oh no, Colony X needs substance Y! Oh no, Federation Bureaucrat Z is preventing us from doing the Obvious Right Thing!). The men on the surface act ridiculously, and of course, we also have the puerile adolescent fun of a planet full of ditzy miniskirt babes who are hungry for male contact. The pain acting is … painful.

The largest and worst species of problems in this episode of course arises from the idea that they have to take Spock with them to the surface. Honestly, how much could this episode have been salvaged without the remote controlled Spock? You're telling us that McCoy doesn't know how to re-implant a brain, but Scotty knows how to rig up a radio control? The grinding gear sound effect was beyond ridiculous. I maintain that, minus that visual, people would remember this as a middling show with a pretty decent concept.

At the conclusion of the show, we get he same old flouting of the prime directive that mars other episodes such as "The

Apple," "Return of the Archons," and so many more – you don't need your current way of life! We'll fix it for you!

I think on balance, this is a deeply flawed episode with a lot of really bright spots. As such, I don't see it as in the same echelon as stinkers like "The Apple," "Catspaw," and "The Way to Eden." Really, the episode that it most reminds me of in a way is *TNG*'s "Justice." It will forever live in infamy as the source of some of the franchise's stupidest scenes, but when you really get down to it, it has some good nuts and bolts, and was probably an edit or five away from being really good.

11

The Softer Side of Spock

Renea McKenzie

When Kevin asked if I would write a guest post for Spocktober, I was honored because Kevin's expertise and the quality of work on The Undiscovered Country Project are unmatched; and I was thrilled because, well, everybody loves Spock! It's given me the perfect excuse to go back and watch several of the original episodes and movies. I've really had a lot of fun.

My favorite film in 2009 was JJ Abrams's *Star Trek* (quite a feat for the Star Trek franchise and Mr. Abrams to be able to beat out my obsession with Harry Potter, which released *The Half-Blood Prince* earlier that same year). I saw *Star Trek* with my mom who grew up watching The Original Series. At some point after the film she commented that young Spock would never have had a girlfriend, let alone Lieutenant Uhura. She was right, of course. TOS Spock succumbs to love/romance only when drugged ("This Side of Paradise"), forced via telekinesis ("Plato's

Stepchildren"), or as a result of devolution ("All Our Yesterdays").

Kevin, who understands the nuances of The Original Series better than I do, will have to comment as to what kind of statement the show is making, if any, regarding Reason vs. Emotion on the Star Trek value hierarchy. From my armchair, I suggest Spock and Bones are foils of each other, the one inordinately logical, the other excessively passionate, and Kirk, the hero, the ideal, lands in the middle somewhere. Or, and I like this a little better, the three work together to form a literary "soul triptych" where Spock represents the mind, Bones the body, and Kirk the soul, in which case none is complete/ideal without the others and things get messed up when they get out of rank: soul, mind, body.[7]

At any rate, in the Abrams film, we see the softer side of Spock, much to the chagrin of cult fans everywhere. By softer, I am not solely referring to the romance between Spock and Lt. Uhura. I mean to suggest that Spock 2.0 is more emotionally expressive overall, which makes him softer, or more vulnerable (in the best sense), including when his emotions find expression in sarcasm or anger.

Throughout the whole film, even when Spock is most logical, "Zachary Quinto's facial expressions and body language

[7] Editor's Note: I agree, for the most part, with Renea's assessment, though I have a hard time classifying the passionate, hot-headed Bones as the "body" (even if his nickname fits nicely with that designation). The Kirk/Spock/McCoy triad has also been compared to Freud's Id (Bones), Ego (Spock), and Superego (Kirk), with some success. But, to the essential question Renea brings specifically to me here—that is, the contention between reason and emotion in Star Trek—I would say that Spock and Bones, most basically, represent those two not entirely separate concepts. And, in true yin-yang fashion, neither is entirely without a bit of the other within himself (especially considering *Star Trek III*). But, essentially, Kirk tends to listen to an external dialogue between Spock and McCoy that mirrors the internal dialogue between reason and emotion. The balance he finds is what we call morality. The moral of Star Trek is often just that—balance. And balance between reason and emotion is what Star Trek seeks.

are significantly less stoic than Leonard Nimoy's (in The Original Series, though Nimoy himself is less stoic in this film, as Spock Prime)."

Quinto has compelling emotional depth behind his eyes that, as Spock, serves him quite well. As we all know, Vulcans are not emotionless; their emotions run deeply, but surface rarely. We get the feeling from Quinto that there is always something going on inside Spock beyond the reaction he gives, whether it be deep emotions or deep thoughts.

When Spock stands before the Vulcan Council to receive news of his acceptance into the Vulcan Science Academy, the Council President refers to Spock's human mother (and, therefore, his human blood) as a "disadvantage." In reply, what Spock says with his mouth is a calm, "Ministers, I must decline." But look at his face; his eyes say, 'Take your Science Academy and shove it.'

The issue of Spock's mother, his sensitivity regarding her and his tenderness toward her, is not new with the reboot. *TOS* Spock regrets his inability to express love to his mother, among others, in "The Naked Time." This rare and raw expression of emotion happens, similarly to the Spock-as-lover episodes above, as the result of Spock's having contracted a virus. In this scene, Nimoy portrays powerful emotion through pained eyes and facial expressions. The difference, then, between old Spock and new, is that young Spock's emotional signals do not derive from extenuating circumstances (such as poisons and diseases) and are constant throughout the whole film, including moments when young Spock is in control of his emotions.

We see a level of this—emotion without extenuating circumstance—from Spock 1.0 in *The Wrath of Khan*. Spock shows concern and possibly pity, which is to say, compassion, in his exchange with Admiral Kirk after he gives Jim *A Tale of Two Cities* for his birthday. We see heavy sadness from Captain Spock when Scotty brings a fatally wounded crew member to the bridge. Spock warmly repeats the phrase, "I have been, and always shall be, your friend," to Jim, and of course, most compelling are Spock's last few moments before his sacrificial death. Nonetheless, it takes a mind-meld with V'GER in *Star Trek: The*

Motion Picture for Spock to reach the place of emotional security and self-assurance he expresses in the second film. Spock empathizes with V'GER's quest, and through her, Spock learns that pure logic is not good, by which I mean virtuous, in part because it leaves no room for beauty; in logic alone there is no ultimate meaning or hope. Spock seems to be asking alongside V'GER, "Is this all that I am? Is there nothing more?" The biracial Vulcan-human finds his answers, and it is unnecessary to return to Vulcan or attempt to complete Kolinahr.

All that being said, the argument remains: young Spock, having not experienced all that lead to the original Spock's emotional enlightenment, logically should be less emotional than he is portrayed in the Abrams film, alternate universe or no. I believe, however, there are valid and unavoidable reasons why Spock 2.0 must be more viscerally passionate than his predecessor. The evolution of TV includes a shift from melodrama to drama, facilitated in part by the simultaneous use of multiple cameras in dramatic films and television series.

Spock 1.0's extreme stoicism derives in part from TV's melodramatic heritage. In the fight between Kirk and Spock on the bridge, we see this McLuhan-esque point illustrated—the need to match the level of emotional intensity with that of the modern-day fight scene and super-close close up—and Abrams' and Quinto's overarching dedication to The Original Series.

Finally, I suggest rebooted Spock is more outwardly emotional, and is explicitly encouraged to be so by both his father and his future self because, just as we expect modern technology and special effects in throwback film, we expect modern sensibilities. Thanks in part to the Star Trek generation of the 60s, we are more in touch with our emotions as a society, and we expect, we need, art to connect to us in this way—and this is what art does; it reflects society back on itself. The evolution of Spock connects to us in this way, allowing the underlying messages of the Star Trek mythology to connect as well.

12

The Works of Spock's Hands . . . and Ours

MIKE POTEET

What's Mister Spock's most distinctive physical feature? His pointed ears? Not a chance. It's his hands.

No, I'm not joking. Think about it. Have you ever stopped to consider just how much the character of Spock is defined by how he uses his hands?

The Vulcan salute almost makes my entire case for me. Has any other fictional character's hand gesture so thoroughly permeated popular culture? The only other possible contender I could name would be Fonzie from "Happy Days," but Henry Winkler's heyday was a long time ago, and I bet his thumbs-up and accompanying "Aaaay!" would draw blank stares from a lot of folks today. But the hand sign Leonard Nimoy introduced persists in the general public's consciousness. (Since you're reading a blog about Star Trek and religion, you likely already know that Nimoy "stole" the sign from orthodox Jewish tradition.)

As fans, of course, we can think of many more trademark ways that Spock uses his hands. Picture him, for instance, sitting at the Enterprise briefing table. Where are his hands? That's right: gently folded in front of him, the index fingers raised and touching each other. I think every Star Trek novel I've read that features Spock includes at least one instance of the phrase, "Spock steepled his fingers…" It's a gesture connoting contemplation and wisdom.

Or think about two of Spock's favorite off-duty activities: playing chess and playing the Vulcan lyre. "Charlie X" gives us glimpses of both. In the chess scene, Nimoy's hands convey Spock's detached confidence in his match against Charlie — folded and at rest when the move is not his, unhurried and decisive when it is.

And, earlier in the episode, Nimoy's hands convince viewers that his alien instrument could really make music, as he subtly adjusts its settings and strums its strings. But make no mistake, Spock's hands mean business when they need to. Have any of us not wished, at some point, that we, too, could master the Vulcan nerve pinch?

Nowhere, though, does Nimoy demonstrate his awareness of the importance of Spock's hands more dramatically than in the Vulcan mind meld. Originally meant by Nimoy and the Star Trek creative team to be used only sparingly, this ancient Vulcan technique for probing another's thoughts, memories, and feelings eventually became an irresistibly expedient plot device, so it's best to watch the earliest meld — Spock's contact with the neurally neutralized mind of Dr. Simon van Gelder, in "Dagger of the Mind" — to appreciate how methodically Nimoy works to create this enduring facet of Vulcan lore. As Nimoy himself said, introducing this scene in the 1982 TV special *Star Trek Memories*, "Pay particular attention to Spock's hands."[8]

A lesser actor would rush right through that scene, relegating it to the status of "business." Not Nimoy. He rubs his hands together, to suggest Spock is summoning strength for the

[8] https://www.youtube.com/watch?v=Q7rrc7oJGPQ

effort to come. He takes a few seconds to secure van Gelder's forehead and chin, implying this is serious work, not to be undertaken lightly. When he starts to circle around, he never breaks contact with van Gelder, but shifts his fingers' positions ever so slightly, finding (we imagine) just the right pressure points. As with the Vulcan lyre, Nimoy "sells" the Vulcan mind meld. While not every future mind meld would be so disciplined and deliberate (culminating in the unforgivably sloppy "infodump" meld at the center of J.J. Abrams' 2009 Trek film), the care Nimoy took in establishing the practice here cemented its believability for decades to come.

All of which made something I learned about Spock's most famous meld, the transference of his katra to Dr. McCoy, surprising.

I'd long wondered why the scene as we see it in *Star Trek III*, as Kirk reviews Spock's final moments in footage from the Enterprise's flight recorder, is clearly not footage from *Star Trek II*. Kirk sees (courtesy of the credulity-straining sophistication of twenty-third century security cameras) a smooth, unbroken two-shot. The camera tracks Spock and McCoy as the good doctor crumples to the floor and zooms in on Spock's mouth for the pivotal command, "Remember." In *Star Trek II*, however, where the moment takes place "in real time," we in the audience don't see that seamless shot. Instead, a cut occurs between Spock's pinch of McCoy's neck and the moment of the meld itself.

The explanation for this discrepancy is simple—and simply illogical. The hand touching DeForest Kelley's face is not Leonard Nimoy's. As Nimoy told an interviewer, "Unbeknownst to me, they decided that they needed a closer insert of a hand going onto McCoy's face, which obviously should have been my hand. For some reason or other, either I was unavailable or maybe they didn't want to pay me, they had somebody else put their hand on McCoy's face, and it was done in a very clumsy, indifferent kind of manner which I've never forgiven them for. I get angry about that kind of stuff. It's a very important character issue, and whoever put their hand on McCoy's face didn't know

that. They just simply plopped some fingers onto his face in no particular way and with no particular interesting definition."⁹

The inclusion in *Star Trek III* of the scene as it was filmed for *Star Trek II* only partially mitigates the mistake. The difference may seem small, but, as his years of work with Spock's character clearly demonstrates, the way we use our hands matters!

Ultimately, of course, life goes on—for Spock in the Star Trek franchise, of course; but also, and more importantly, for us. But reflecting on Nimoy's use of his hands leads me to reflect on how I use my own. I'm not an actor, so I don't "work with my hands" in the way he does; nor do I "work with my hands" in the sense in which most people use that phrase. At the office, I use my hands to answer the phone, type, and flip the pages of rare books. It's a good job for me, but I'm under no illusion that it's physically demanding.

But, like everyone, I am capable of "working with my hands" to do other things. I can use them to touch others in friendship or love, or I can ball them up into fists of anger and resentment. I can open them in generosity to share with those who are less fortunate, or I can close them in complacency and selfishness, stuffing them deep into my own pockets. I can raise my palms to heaven in praise and prayer, or I can point my fingers at others' supposed faults, or at my own supposed merit or achievements.

Psalm 90 closes with this petition: "Let the favor of the LORD our God be upon us, and prosper the work of our hands— O prosper the work of our hands!" (Ps. 90.17, NRSV). But, as I'm sure the psalm-singers would have agreed, not everything we human beings do with our hands deserves to be prospered. As creatures who can, in our own turn, create, we no doubt do many good things with our hands, but we do many bad things, as well—and the biblical witness is that we, on the whole, do more of the latter than the former. We reach out for forbidden fruit and build towers to the skies to make our name great. We fashion

⁹http://www.leonardnimoy.de/index.php?option=com_content&view=article&id=1276:he-was-so-human-really&catid=23:articles-and-quotes&Itemid=11

idols and graven images. We lash out in anger; we injure; we kill; we steal; we destroy. Our hands, like the rest of us, are stained with sin.

The good news is that, as he does the rest of us, Jesus Christ redeems our hands, sanctifying them and showing us how to use them for his holy purposes. Watch his hands, for example, as he stretches them out to heal a man plagued by skin disease (Mark 1.41). Watch them as he takes up little children in his arms — weak and vulnerable, often regarded as not worthy of attention — to bless them (Mark 10.16). Watch them as he ties a towel around his waist, pours water into a bowl, and washes his disciples' dusty, calloused feet, as a household slave might, but with more care and compassion (John 13.4-5). Watch them as Roman soldiers nail them to the rough wood of a cross, where Jesus will "work with his hands" the salvation of the world before commending himself into the hands of his Father (Luke 23.46).

If Spock's hands deserve our attention, how much more so do the hands of Christ! They are the hands of God: bone of our bone and flesh of our flesh, the hands of the One through whom all things came into being, the hands that shaped us and the cosmos in the beginning and the hands that will make all things new in the end. And we recognize them by their scars, the wounds that mark them, always and forever, as hands of divine, self-giving love.

Margaret Cropper has written a lovely hymn[10] — perhaps intended for children, but one that all of us could profit by singing — which reminds us that "Jesus' hands were kind hands, doing good to all," and which prays, "Let me watch you, Jesus, till I'm gentle, too; till my hands are kind hands, quick to work for you." May you and I use our hands to do kindness and justice as we walk humbly with our God. May the Holy Spirit direct our hands to do work that God will (with apologies to both Spock and the psalm-singers) see fit to make live long and prosper.

[10] http://www.hymnary.org/hymn/SWM/222

2013

13

Spockrates and the Nature of the Emotions

MARK J. BOONE, PHD

For a few years, I have wanted to write a post for UCP on the episode "Catspaw" from the *Original Series*, but it's been hard to find time to write an essay that would handle the various relevant issues as delicately as they deserve. (Those issues are Spock, Halloween, the emotions, Socrates, and Christianity.)
I *still* don't have time to write such an essay and handle these issues delicately! So instead I'm writing this post and cutting to the chase most indelicately. The advantage to my lack of time is that this post will be quick and to the point. Quick and to the *four* points, to be more precise.

The background: "Catspaw" is a great (and rather campy) sci-fi Halloween episode. There's no horror; but there *is* spookiness. The *Enterprise* crew encounters some aliens from beyond the galaxy. The aliens try to tap into their minds, but only reach

their *sub*conscious minds. There, they access various things humans have feared — witches, spooky castles, black cats; they create illusions of these things in order to test Kirk and the others.

First point: Spock does not fear because he knows there is nothing to fear. The spookiness just doesn't get to him. He knows being afraid of it is irrational.

Second point: Spock illustrates a thesis concerning the nature of the emotions: that emotions convey information about a situation. Fear, in particular, is not an empty emotion. It means something. To be afraid of something is to perceive it as a bad thing. It is precisely because he does *not* think these things are bad that he does not fear.

Third point: This thesis is also Socrates' thesis about the emotions in Plato's *Apology*. (This is a text that you should probably *read* if you haven't read it already; in the meantime, I offer you my cartoon version of the *Apology*.[11])

I don't necessarily agree with everything in Socrates' definition of the emotions. I think Robert Roberts' book *Emotions: An Essay in Aid of Moral Psychology* develops this thesis in the right way.[12]

Fourth point: If the emotions do indeed have content, this has relevance for the Christian life. Emotions are shaped by our understanding of the things that are important to us. Roberts has written a good book[13] on what understandings should be shaping the emotions of a Christian. It's very insightful, but still quite readable. I recommend it.

[11] https://www.youtube.com/watch?v=11H_qkkLwUY
[12] Roberts, Robert C., *Emotions: An Essay in Aid of Moral Psychology*, Cambridge University Press, 2003.
[13] Roberts, Robert C., *Spiritual Emotions: A Psychology of Christian Virtues*, Eerdmans, 2007.

14

In Search Of . . .

MIKE POTEET

The fact that Halloween falls at the end of "Spocktober" reminded me of my introduction to Leonard Nimoy. It wasn't *Star Trek*. I wouldn't start watching syndicated reruns and becoming a Trekkie until 1984, in seventh grade. No, I'd first encountered Nimoy's work several years earlier, in a non-fiction venue—and it terrified me!

From 1977 to 1982, *In Search of...* investigated an astonishing range of unexplained mysteries (long before Robert Stack came along.) UFOs, the Loch Ness Monster, Atlantis, Amelia Earhart, Dracula, the lost colony of Roanoke—nothing escaped the series' seemingly all-encompassing embrace. Each week, Leonard Nimoy presented facts, suppositions, theories, and wild conjectures—"some possible explanations," the disclaimer at the top of each episode cautioned, "but not necessarily the only ones, to the mysteries" being examined.

Being a kid whose imagination was stuck in overdrive, I watched *In Search of...* as faithfully as I would one day watch *Star Trek*. Most weeks, I loved it! It prompted me to "what if" questions that sent me scurrying to my elementary school's library to learn more. I remember reading books about mummies, dinosaurs, the possibility of intelligent life in outer space, and psychic powers, among other subjects. (I even remember making my own set of cards to test for ESP potential. The results were, alas, discouraging.) Prompted by Nimoy's solemn, Spock-like tones, I explored more topics than I otherwise might have. While I wasn't always separating fact from fancy, any more than *In Search of...* was, I was having a great time.

That all changed when I watched "Killer Bees." You can watch the episode, too—*if you dare!*

This program probably wouldn't spook me today, but as a kid, this installment scared the living beeswax out of me! At one point (as I recall... I still haven't rewatched the thing), the screen displayed a map of killer bees' projected path into North America: a big, blood-red blob spreading inexorably north. And all the while, Nimoy was holding forth on how there was little, if anything, we could do to stop them.

Absolutely convinced I'd awaken one morning to find a wall of stinger-wagging, honey-dripping *death* outside my door, I ran screaming into my parents' bedroom, sobbing and shaking. This was how the world would end—not with a bang, but with a sticky buzz!

In the 1990s, when reports about discoveries of pockets of killer bees made the nightly news, I would immediately think of *In Search of...* "Sure enough!" I thought. "Nimoy was right!" But I was no longer scared. I appreciated that Africanized honey bees were (and are) a real ecological problem, but the more I listened calmly to accurate information about them, the more I realized they weren't the entomological Armageddon I'd anticipated as a little kid.

I wonder what Mr. Spock would think about *In Search of...*? As Admiral Kirk pointed out to Saavik in *Star Trek II*, Spock is fond of saying, "There are always possibilities." Spock would be the last person to dismiss a possibility, however far-fetched it

might initially seem, out of hand. However, so many of the possibilities *In Search of...* advanced—the ones that make for gripping "reenactments" and dramatic "revelations"—*were*, in fact, far-fetched, and don't stand up to logical scrutiny. If anyone is synonymous with logical scrutiny, with wanting to know truth instead of falsehood or groundless speculation, it's Spock. As he told Kirk in "Space Seed," "Even a theory requires some facts." (Being a scientist, I can only assume Spock was using the word "theory" in its popular sense of "hypothesis," since scientific theories are rooted and grounded in facts!)

Whatever he might think of *In Search of...* I know Spock would have encouraged my scared seven-year-old (or so) self to have treated the "killer bees" no differently than I had any other subject from the show. Listen carefully and calmly to accurate information. Read and ask questions. "Learn all that is learnable" (as V'Ger well knew). And—to quote another famous sci-fi franchise for a moment—don't panic! Confront fear. Refuse to let it have the upper hand. Don't run away from what is frightening—face it!

$$\frac{2014}{2015}$$

15

Mr. Spock: Scientist

A. BOWDOIN VAN RIPER

Something remarkable happened to *Star Trek* between its two pilots and its regular network run: Mr. Spock developed an identity. Part of the transformation was personal. Spock, calling "Damage reports! All stations!" in "Where No Man Has Gone Before," sounds distinctly human; he could be the Chief-of-the-Boat in a submarine movie. By "The Man Trap," the first-aired episode of the series proper, however, Leonard Nimoy had found his inner Vulcan, and Spock had become genuinely, fascinatingly *alien*. The other piece of the transformation — important for the character, but even more so for the series — was professional. Spock became a scientist, and *Star Trek* was transformed.

Spock's role as Science Officer was not an idle choice. His presence on the bridge, like the presence of an African communications officer, a Japanese helmsman, and (in time) a Russian navigator, was Gene Roddenberry letting his liberal-

humanist flag fly. "Our missions are peaceful—not for conquest," Kirk tells a skeptical alien emissary in "The Squire of Gothos." And we believe him, because we already know that aboard the *Enterprise*—the most powerful warship in the Alpha Quadrant, which can outrun light and reduce enemies to clouds of atoms in an instant—the second-most-important member of the crew is the chief scientist.

There had been scientists in science fiction television before Spock, but none so central. They tended to be supporting characters who gave advice to the hero from the sidelines (like Professor Newton of *Rocky Jones, Space Ranger* in the 1950s) or conventional heroes whose identity as scientists existed mostly in pilot-episode dialogue (like John Robinson of *Lost in Space*). Spock, in this way as in so many others, was different. Thanks to literate scripts and Nimoy's performance, his "scientist" identity was apparent onscreen every week: not just a job description, but a central part of who he *was*.

Ask a scientist what they're up to, and chances are excellent that their response will begin with some variant of "I'm trying to understand X." So it was, throughout the run of the Original Series, with Spock. When the *Enterprise* encountered an unknown, unexplained, and potentially lethal phenomenon—as it did every second or third episode—Spock's reaction consisted, time and again, of a single word: "Fascinating." Kirk might be determined to complete the mission, McCoy anxious about the well-being of the crew, and Scotty wary of the threat to "his" ship, but every bit of Spock's attention would be focused outward: making observations, gathering data, attempting to understand. On landing parties, Spock's ever-present tricorder substituted for the sensors that fed data to his workstation on the bridge, but the effect was the same. The body language and facial expressions that Nimoy brought to those moments conveyed total absorption. More than just a highly trained crew member doing his job—gathering information that might be needed later—Spock was, in those moments, immersed in the most basic of all scientific activities: being curious.

Science does not live, however, by curiosity alone. Curiosity—and the wide-ranging, never-ending engagement

with nature that it fuels—provides the data. Reason, applied relentlessly and impartially, makes sense of that data: detecting patterns, drawing connections, and assessing significance. Spock's embrace of Vulcan culture, with its exaltation of rationality and denigration of emotion, made him a scientist *par excellence*. He followed the data *wherever* it led, permitting no safe havens for things that "everyone knows" or that his closest friends desperately wanted to believe. It is Spock who, in "The Man Trap," forces McCoy to realize that his long-lost lover Nancy Crater is a lethal, shape-shifting alien, and Spock who flatly states the inescapable reality that (as David Gerrold notes) gives "The City on the Edge of Forever" its poignancy: Edith Keeler must die, and James Kirk must lose her. The relentlessness of Spock's rationalism also, however, offers hope. He alone sees through the surreal "Old West" created by the Melkotians in "Spectre of the Gun" (and thus sees a way out of it), because he trusts reason more than his own senses: "Physical reality is consistent with universal laws. Where the laws do not operate, there is no reality. All of this . . . is unreal."

Scientists' dismissal of "truths" that "everyone knows" but rationally analyzed data does not support goes hand-in-hand with a willingness to accept "impossible" things that rest on a solid analytical foundation. Pioneering geologist John Playfair expressed amazement, two centuries ago, at "how much further reason may sometimes go, than imagination is willing to follow." Spock's encounters with alien life were, in episode after episode, a testament to that willingness to follow scientific reasoning deep into the realm of the (seemingly) impossible. Kirk may have the best dramatic moment in "The Devil in the Dark"—protecting the Horta from an angry mob of miners and declaring that "the first man who fires is dead!"—but that moment (and its message of interspecies understanding, which makes the episode one of *Trek*'s finest hours) rests on a series of much quieter scenes. Spock is at the center of every one of them, first noting that the planet harbors "no life as we know it," then theorizing that life based on silicon rather than carbon is possible, and finally discovering (via mind-meld) that silicon-based life can not only exist, but be sentient and rational.

Every episode of the Original Series opened with a series of ringing infinitives, two intact and one magnificently split: "to explore . . . to seek out . . . to boldly go . . ." They laid out the mission of the *Enterprise,* but they could serve, equally well, as a mission statement for science itself. It seems fitting, then, that the captain of the *Enterprise* went forth into the galaxy with the most eminent scientist in the history of science fiction television at his side.

16

Punk on the Bus: An Encounter with Christ in Star Trek IV

KEVIN C. NEECE

One of the most memorable scenes in *Star Trek IV: The Voyage Home* is when Kirk and Spock take a ride on a San Francisco bus. Across from them is a punk with spiked hair and a huge boom box, blaring a loud, angry punk song. After Kirk makes repeated attempts to convince the belligerent young man to turn down his music, Spock simply reaches across the aisle and gives their obnoxious fellow passenger a Vulcan nerve pinch. The punk slumps forward, his unconscious face coming down to shut off the boom box. The passengers on the bus cheer and applaud — and so does the audience.

In this iconic moment, Associate Producer Kirk Thatcher makes his film-acting debut playing the "Punk on the Bus." Thatcher also wrote and recorded the song "I Hate You," which plays on the punk's boom box. In this scene and its accompanying song lies a surprisingly rich bit of unintentional

symbolism that yet again reflects a Christian worldview and Spock as a Christ figure. We'll start with the lyrics of "I Hate You."

> Just where is our future?
> The things we've done and said
> Let's just push the button
> We'd be better off dead
>
> 'Cause I hate you
> And I berate you
> And I can't wait to get to you.
>
> The sins of all our fathers
> Been dumped on us, the sons
> The only choice we're given is,
> "How many megatons?"
>
> And I eschew you
> And I say, "Screw you!"
> And I hope you're blue too
>
> We're all bloody worthless…

In the film, the song is cut off there. The full song is available on a special edition of the *Star Trek IV* soundtrack, but there isn't much more to the lyrics. [14] It was a very off-the-cuff composition by Thatcher, who wanted something that sounded like a real punk song blaring from the boom box's speakers in the scene. Though, of course, I can't let it stand at that. As I viewed *Star Trek IV* in the context of Spock's status as a Christ figure, one of many seemingly unimportant elements that stood out to me as suddenly imbued with new, unintended meaning was the song,

[14] For the record, they are: "Just greedy human scum/The numbers all add up to a negative sum/'Cause I hate you/ And I hate you/And I hate you too!" (Repeat from the beginning, through "megatons")

"I Hate You." I know. I was as surprised as you are. But here we go.

The punk on the bus and the lyrics of the song "I Hate You" represent all the lies of the Accuser and the darkest state of humankind's heart in the depths of our sin. As represented here, we are damned by our actions and doomed to destruction, with no hope of salvation and no worth or value. The inverted cross on the punk's earring signifies him as the most utterly lost—not only without Christ, but in direct rebellion against him, fully embracing the oblivion and hopelessness of life without him. He sees no future but damnation.

He's not a villain, but he does stand in opposition to the hope that Spock—and indeed Star Trek—represents. The first line of the song, "Just where is our future?" is a very Star Trek signal of hopelessness. In Star Trek, hope lies in the future, in a perfected version of humankind and of human society. "I Hate You" puts itself in immediate opposition to that idea by expressing at the very least uncertainty, if not utter pessimism, about the future.

At the same time, the line asks, "What is our destiny? Where are we going as a society, as human beings?" The question of destiny is an essential one for a Christian worldview perspective—not just in the sense of whether one ends up in Heaven or Hell, but whether there is hope for the human race and for this planet. A robust Christian worldview recognizes the hopelessness and despair of the human race, but ultimately sees redemption and restoration as humankind's final destiny.

The next line, "the things we've done and said," seems to find a source for the hopelessness of the first line and of the song. Our future is bleak when viewed from the perspective of human actions. A Christian perspective certainly agrees. Our sinful nature, expressed in our hateful, selfish and thoughtless actions, is the source of human misery. This misery and hopelessness is expressed in the lines, "Let's just push the button/We'd be better off dead." This sentiment is not only suicidal, but also genocidal, seeing annihilation as the only escape.

With the phrase "Let's just push the button," it also seems to be referring to nuclear destruction. Throughout this film,

humankind's relationship with nuclear power, especially in the form of weaponry, is a recurring theme. From Spock's discussion of an ill-fated "flirtation" with fusion reactors in the 20th Century to newspaper headlines about stalled nuclear arms talks, the film quietly comments on what a 23rd Century perspective sees as self-destructive foolishness. The punk on the bus seems to share this distaste for nuclear arms, but from a perspective that feels doomed by their escalating presence during the height of the Cold War.

In "I Hate You," the title phrase emerges as a direct result of the feelings of hopelessness expressed in the opening lines. Who does the punk on the bus hate? Though his hatred is surely focused most strongly on anyone he sees as "part of the problem," particularly authority figures, it seems to spill over to pretty much anyone and everyone around him. His general misanthropic perspective is a natural outgrowth for someone who hates himself, who sees nothing redeemable about humanity, in part, because he sees nothing in himself that, he believes, can be saved. His expression of outward malice emerges from inward discontent.

I've established in my audio commentaries for the Genesis Trilogy (*Star Trek II – IV*) the idea of Spock and Kirk as symbols of Christ and the Church. If we continue to interpret these two characters in this way, the relationship between the two men and the punk takes on some interesting new shades of meaning. What's interesting in this scene is that, as Kirk becomes annoyed with him, the punk's hatred and disgust are directed more and more at Kirk and Spock. Both Christ and the Church often become targets of anger and we'll see more of this as the scene progresses.

The line "I hate you and I berate you" certainly describes the punk's actions in the scene, reinforcing the idea that the song represents the thoughts and feelings of the punk within the scene, almost as a projected inner dialogue. But the next line, "I can't wait to get to you," takes an interesting turn. Intended as an expression that the punk wants to "get to" someone in order to do them harm, the line could be read affectionately as saying, "I can't wait to be near you." Indeed, if this same line appeared in a

love song, this is exactly how we would interpret it. So, as the punk rebels against Spock/Christ and says to him "I hate you," it could be argued that he simultaneously expresses a desire to be near him. This desire is hardly conscious, but often exists in someone who is so dedicated to rejecting an individual or an idea. The line between love and hate is often thin, as both involve intense focus on and passion toward another. Indeed, hate is often the emotional response of one who feels their love is spurned, unrequited, or, as with the punk on the bus, hopeless. Hate happens when we give up on love.

Like the romantic comedy in which the man who most irritates the leading lady is really the one she cares for the most, or the longtime enemies who ultimately become good friends, often our hatred is directed at the thing we most need and deeply desire. When our hearts are rebellious, we tend to lash out most strongly at that which is most likely to cure our present condition. The punk doesn't want to be cured. He finds his whole identity and a sense of personal power in his anger and hatred. The prospect of being released from those things is the prospect of being forced to redefine himself. His fear of that challenge compels him to burrow even more deeply into his hateful persona.

In the same way, we often choose devotion to a rebellious, sinful life because we are afraid of the challenge presented by a Jesus who is real and who threatens to change us at the heart level. We know that, if we love him, we will change. That prospect is frightening because we've come to find comfort in our present state, even if that state is one of hopelessness and self-abuse. Like a hoarder addicted to a mountain of junk and trash inside their own house, we find security in our own sense of damnation.

The next verse of "I Hate You" puts an even more specific name on the reason for human misery. Reflecting a line from Scripture, it says, "The sins of all our fathers been dumped on us, the sons." This points back to a human heritage of sin as the source of our despair. Indeed, a Christian worldview again sees the same problem, but has a different answer. The statement that our fathers' sins have been "dumped on us" expresses again that

damnation has come, whether we feel we asked for it or not. Reflecting the Biblical truth that the consequences of our actions echo into future generations, this line expresses the inherent unfairness sensed by the recipients of each successive generation's legacy of ills.

This inheritance is certainly ours outside of grace, but Christ offers us a new inheritance as we become sons and daughters of God. It's an inheritance that was intended for humankind from the beginning but which, like the Prodigal Son of Jesus' parable, we have squandered and have failed to appreciate. The punk on the bus may look to us like an outsider—a person we look on and pity, who is not like us—but the rebelliousness in his heart lives in the whole human race. The punk sees this and it drives him to despair.

The next line of the song, "The only choice we're given is 'How many megatons?'" returns to the nuclear arms imagery from earlier in the song. The fear of nuclear annihilation is essentially an expression of the fear of our own power to destroy ourselves. The idea that we—as a human race and indeed as individuals—are our own worst enemy is deep in the human heart. It is reflected in fears of all sorts of new ideas and new technologies and is perhaps indicative of the fact that we inwardly know that our own sinful nature is our downfall.

Star Trek's optimism that, as Gene Roddenberry said, "There is a tomorrow. It's not all going to be over with a flash and a bomb," stands in stark contrast to this idea. Star Trek says that it is not technology itself that we should fear, but that the real danger lies in the human heart. When our moral and spiritual development is outpaced by our technological development, the corruption in our hearts will overtake us. If, however, our hearts can move beyond corruption, our use of technology will be a positive development.

Unfortunately, Star Trek falls short in its ability to describe how the human heart can be rescued from itself. Its undergirding idea that humanity itself is the answer is ultimately weakened by the Star Trek narrative itself, which must constantly deal with the brokenness in the human soul, even in its idealized 23rd and 24th Centuries. Of course, Star Trek does point to the

ultimate answer for the human condition, whether it knows this or not, by portraying strong Christ figures like Spock.

It is at Spock and Kirk that the final verse of "I Hate You" is emphatically directed. "And I eschew you," the song says, following with, "And I say, 'Screw you!'" at which point, the punk jabs his middle finger in the air in Spock and Kirk's direction. Kirk has been trying to get the punk to turn down his music, at first politely and then loudly. At Kirk's first request, the punk simply turns up the volume on his boom box. When Kirk shouts, "Would you mind turning off that damn noise?" the punk responds with the aforementioned hand gesture. "And I hope you're blue too," the lyrics announce. Mission accomplished. The punk has managed to spread his misery around quite effectively.

As we again look at Spock and Kirk as Christ and the Church, we see that the Church may often be justified in calling the despair, hopelessness and hatred around it "damn noise," as indeed this noise represents the stuff of damnation. Kirk's efforts, however, are fruitless. Perhaps another tactic would have been more effective; one cannot say for certain. While one would hope that the Church would find a way to do more than encourage its surrounding culture its increase its noisy defiance, this often seems to be all that many of its current actions can hope to accomplish.

Ultimately, though, it is Spock who has the final word, just as Christ does in human history. Reaching calmly across the aisle, Spock subdues the punk with a trademark Vulcan nerve pinch, causing him to pass out face-first into his boom box, shutting off the sound. Kirk and the other passengers applaud. In the same way, human despair and hopelessness can only be brought to an ultimate end by Christ. Like the punk on the bus, many whose hearts are rebellious will reject every opportunity to turn their hearts toward him and will be silenced. Of course, God's desire is that all would be redeemed.

The last line we hear of "I Hate You" is "We're all bloody worthless." Indeed, we all have a bloodiness about us—blood symbolically on our hands as we stand guilty before our Creator. And we certainly are not worthy of God's grace. But, are we truly

worthless? Like Spock, Christ shuts that idea down immediately. In his deep love and compassion for the human race, he imparts back to us the worth and value we have lost sight of and fall short of embodying. By sacrificing his own life and dying in our place, by conquering death and Hell and giving us the inheritance of eternal life as sons and daughters of God, Christ says that we are not "bloody worthless," but worth his blood.

By the end of *Star Trek IV*, we'll see a beautiful picture of Jesus advocating for us by standing with us at the seat of Judgment and interposing his righteousness for our own, undoing the damage our sin has inflicted upon all Creation. In this way, Spock's encounter with the punk on the bus foreshadows the ultimate restoration that he will bring. It may be a small, comical moment in a fairly lighthearted film, but as all the passengers on the bus applaud Spock, it nonetheless manages to be a picture of the victory of Christ over our sinful nature and the ultimate truth that everyone on the "bus" of the Earth will praise him.

17

Spockrates: The Meaning of Plato's Republic and the Meaning of Life

MARK J. BOONE, PHD

I think the biggest reason Star Trek is such a successful universe of science fiction is that it is just plain good sci-fi; cool spaceships go a long way. But the second-biggest reason is that Star Trek is not just about cool spaceships. It's also about philosophy.

Star Trek is, above all, a series of thought experiments in space. The combination of cool spaceships and philosophy is superb, but in this superb combination it is always philosophy that plays the larger role—or at least it should always be.

In Platonius, the *Enterprise* crew from the Original Series encounters a group of aliens enamored with Plato's Republic. The problem is that they aren't very good Platonists, and they don't understand the Republic very well.

They live in luxury. They live like the kings in the saying "live like kings" — not at all like the philosopher-kings of Plato's Republic, after whom they style themselves.

They have some kind of psychic power which they use to control things without touching them. Having a vague understanding of the fact that Plato taught that not all reality is physical, they fancy that their psychic power is evidence of their philosophic wisdom.

But it's not philosophic wisdom — not even close. Their power is to control physical things and manipulate it according to their whims. It's not Platonic for at least three reasons. Here are three:

- This power is only a power over matter, not a spiritual power.
- This power is rooted in matter; it comes from their bodies.
- This power directs the soul to matter, not away from matter and up to spiritual realities.

As a physical power directed towards physical things, what else would you expect? In the case of the aliens on Platonius, their powers are both an aid to and an excuse for sensual indulgence.

The third reason helps to explain a fourth reason their power is not Platonic: These guys are all selfish jerks! They oppress little Alexander, a dwarf of the same race as they who happens to lack their power. And, of course, they oppress Kirk and company when they fall into their power.

Now this fourth reason is the one Spock calls them on: "Plato wanted truth and beauty, and above all, justice."

One Platonian claims that his world does indeed have justice: "In your culture, justice is the will of the stronger. It is forced upon people by means of weapons and fleets of spaceships. Our justice is the will of the stronger mind." To be fair to Platonius, one theory of justice refuted in Plato's Republic is indeed the reduction of justice to "the advantage of the stronger." But Socrates' definition of justice is different; it is "the having and

doing of one's own" (G. M. A. Grube's translation). This Platonian has substituted psychic power for muscular strength, but has not advanced an inch past the rudimentary corruptions of justice refuted in the Republic.

Kudos to Spock for realizing what terrible, terrible Platonists inhabit the planet of Platonius.

Now why does Platonism matter to the project of Undiscovered Country Project? Well, a thorough answer would involve a few books on the subject of Plato and Christianity. I'm not writing a few books' worth of information on a blog post! But Iwill give you links to three interesting books by Christians that incorporate some elements from Plato. The first link is particularly emphatic of the point the Platonians have so tragically missed: immaterial reality.[15]

[15] Suggested further reading: *The Confessions of St. Augustine*, *The Consolation of Philosophy* by Boethius, and *Mere Christianity* by C.S. Lewis

18

Not as Happy a Birthday

HANK HARWELL[16]

I had been looking forward to my birthday for a several days. Although my wife was scheduled to be out of town that week at a conference, she was due to return on Friday night, and we would be celebrating on Saturday with a visit to an Irish pub in town. While she was away, I thought about spending a little "me time" at my favorite big box book store just browsing.

I should have seen it coming. First, we had been pounded two weekends previously with snowstorms which forced us to cancel many of our church activities, something I really dislike doing. I also had to learn to shovel a precariously steep driveway at our home so that we could get out when the roads were clear enough. Not once, but twice.

[16] A version of this piece appeared on Hank's blog at http://geekklesia.blogspot.com/2015/02/not-as-happy-birthday.html and has been revised and expanded exclusively for this collection.

Two days before my wife's trip, I slipped on a patch of ice, and went down hard. A trip to an orthopedic specialist later, I learned that I had broken my ankle.

Between the lack of sleep and the medications, I didn't enjoy the week like I had hoped. To make matters worse, on my actual birthday, I learned that Leonard Nimoy, the actor who portrayed Mr. Spock on the *Star Trek* TV series and movies, passed away.

Star Trek was one of the earliest geek memories I have. My first real memory of it is a little fuzzy mingling of seeing pieces of episodes on TV as a child, and thumbing through my (much older) brother-in-law's copy of *The Starfleet Technical Manual*. Around the same time, he regaled my younger brother and me with the plot of "The Trouble With Tribbles" episode as a bedtime story. Later, I was exposed to episodes of *Trek* and *Lost in Space*, and was drawn more to the former. There was action, there was space travel, there were ideas and there was humanity. And Nimoy as Spock stood out the most in a show full of standouts. He was the one alien in a show dedicated to learning about "new life and new civilizations." His character was explored even more deeply on the films and the contradictory nature of his descent from a human mother and an alien father was itself a fun examination of what it meant to be different to a kid who had always experienced the difficulty of fitting in. In fact, I never felt like I belonged until my sophomore year of high school.

I was never as socially awkward as the character of Dr. Sheldon Cooper from the sitcom *The Big Bang Theory*, but I tended to be a bookworm and a dreamer. I liked some sports, but would have rather sit in a corner reading a Robert A. Heinlein space adventure novel than go outside and play ball. When I was a freshman in high school, I discovered a magazine dedicated to producing amateur movies which in turn led me to seek out an education in film and television production so that I could make movies and TV series like *Star Trek* and *Star Wars*.

As I got older, I finished college, discovered my true calling, attended seminary and was ordained. However, I never forgot that earlier gravitational pull toward sci fi and fantasy, and

found that there was room in God's kingdom for geekly pursuits, and so I dedicated myself to seeking out way to communicate the old, old story of the gospel message contained in the Christian faith by using the metaphors and stories of genre fiction, including science fiction and fantasy. So many people are much more familiar with the tropes and stories found in popular culture films and television programs than they are the biblical stories. Once upon a time, the reverse was true, but no longer. If they were quizzed, this lack of biblical literacy would be evident. I am now determined to find ways to teach the timeless spiritual lessons found in God's Word using sci-fi, fantasy, superheroes and other genre fiction to really illustrate those messages.

One of the lessons I believe that Spock learned was that adherence to a philosophy of pure logic and a repudiation of all emotion is essentially empty, or as the author of Ecclesiastes would put it, "vanity." Rather, for there to be true fulfillment, one must embrace a sober balance of the heart and the head, where heart refers to the passions, and the head equals the voice of reason. The Apostle Paul correctly teaches that without *love* (*not the emotion, but the choice to put others' best interest ahead of your own*) that any stability of mind and spirit is impossible (I Corinthians 13). Spock displays this kind of love for his friends repeatedly, even teaching the point of sacrificing his very life to save them. Yes, he had achieved a sort of stoicism with regard to his emotions, but at the same time he refers to Kirk and the others as "friends," with all that the word implies.

In the end, I can't consider this to be my most favorite birthdays of all time, for the reasons outlined above. I hope it doesn't come across as whining, because all in all, aside from the major inconvenience, it could have been a lot worse. I am deeply moved by the death of Leonard Nimoy on my birthday, but I am all the more grateful for the influence he had on my early development as a geek, and appreciative of the opportunity I have today to stop and really think about what his decision to play this role has meant not just to me but millions of others around the world. While I cannot claim to have always been his friend, or that he was the most human of all the souls I have met,

I do pray that his legacy and memory would indeed live long and prosper.

19

Spock and Jews in the 1960s

Yonassan Gershom

Most Star Trek fans are aware that the Vulcan salute was originally based on a Jewish blessing gesture. But many do not realize how "Jewish" Spock was in other ways. For those of us who grew up during the 1950s and early 60s, Spock was a breath of fresh air in a world where being Jewish was not always socially accepted. Any positive references to Jews and Jewishness, even if couched in fictional metaphors, were very unusual in the media back then. In this essay, I will explore some of the Jewish subtexts that I see in the Spock character, and their influences on me.

During my childhood, there were very few good Jewish role models on television or in the movies. Especially not in science fiction. This was back when most Jewish actors and writers changed their names to sound more "American." (Harve

Bennett, for example, was born Chaim Fischman.[17]) The hero was always a Stoic White Man of the Aryan Persuasion who never, ever waved his hands around or spoke with a Yiddish accent like the people on my block. Even biblical characters were played as if they grew up in the American Bible Belt. Everybody celebrated Christmas on programs like *Leave it to Beaver*, but there was no acknowledgement of Hanukkah, except maybe to morph it into a "Jewish Christmas," complete with a bogus "Hanukkah bush."

If Jews were included in the script at all, they were usually played as buffoons. A good example of this is DeMille's 1956 classic, *The Ten Commandments,* where Charlton Heston as Moses talks like a Protestant preacher, while Edward G. Robinson (born Emmanuel Goldenberg) played Dathan with stereotypical Yiddish mannerisms. As long as we "knew our place" as Borscht Belt[18] comedians, all was fine. But don't expect a serious Jewish character we could look up to.

Now granted, Spock was not Jewish, but Leonard Nimoy was, and he put a lot of Jewishness into the development of his character. Not the Borscht Belt variety, either. Although there is some humor centering around Spock in the scripts, this was social commentary, not slapstick. As I explained in my book, *Jewish Themes in Star Trek,* it seems that Spock's pointed ears were often used as a stand-in for "big Jewish noses." Not all Jews have big noses, of course, but the stereotype is there. Back in the 1960s, "looking Jewish" could mean being discriminated against in housing, education, and employment. Keep in mind that Star Trek began airing only two years after the Civil Rights Act was passed in 1964. The Borscht Belt itself originated in a time when

[17] Green, Michelle Erica, "Bennett on Jewish Roots and Trek Transformation," *Trek Today*, November 12, 2006.
http://www.trektoday.com/news/121106_03.shtml (While this appears to be information Green obtained from Bennett, other sources list Bennett's birth name as Harve Bennett Fischman.)

[18] Also known as the "Jewish Alps," the Borscht Belt was a string of resorts in the Catskill Mountains of New York that gained prominence from the 1920s to the 1970s. At a time when Jews were not allowed in many clubs and hotels, the Borscht Belt (like Las Vegas) served as a safe haven for Jewish performers and vacationers. Its clubs were famous for their comedy acts, but also featured a wide variety of performers.

many hotels, resorts, and clubs would not accept Jews any more than they would accept African Americans.

Unlike African Americans, who could not change their skin color to "pass," Jews could—and often did—have plastic surgery to change the shape of their noses. Jokes about "nose jobs" became standard fare. Many Jews saw this as the experience from which much of the banter over Spock's pointed ears originated. Although Roddenberry originally conceived of them as a "satanic look," very early in the series the ears became a metaphor for ethnic pride versus assimilation. Whenever Spock wants to pass for Human, he covers his ears—in effect, giving himself a temporary ear job. On the other hand, in scenes where Humans are supposed to realize that Spock is an alien, the camera indicates this by zooming in on the pointed ears. And we Jews got the point.

Spock's vegetarianism was also a Jewish subtext for me, given that Jews have a complex set of dietary laws that often prevent us from sharing food or eating out in restaurants. The kosher laws (which go way beyond not eating pork) require special accommodations, the same as how Spock's vegetarianism sometimes gets in the way of diplomacy. And, by the way, I am now a vegetarian myself. This is not entirely due to Spock, but he was definitely an influence in moving me toward that direction. I now believe that vegetarianism is the purest, most humane way to keep kosher.

Perhaps the most Jewish of Spock's characteristics is his intellectualism. Spock's world is ruled by precise, disciplined, and logical thinking, as well as clearly defined social behaviors, in ways that are very similar to Orthodox Judaism in approach. In *Star Trek V*, when Spock researches the customs for camping out before going to Yosemite with Kirk and McCoy, he is behaving in a very Jewish manner. In the traditional Jewish world, this is exactly what people do when entering unfamiliar situations; they look up the laws and customs that apply, and what behaviors are expected of them. And it is also what I do in my own life.

Judaism places great value on education and developing the mind—so much so, that "illiterate Jew" is an oxymoron. An

old Jewish joke says that a Jewish dropout is somebody who did not get a Ph.D. Books are such a major part of Jewish life that they are prominently displayed as part of the décor. Every Jewish home I've ever visited was overflowing with the printed word. Spock does not collect physical books, of course; he uses computers. However, the idea is the same. He is the keeper of the *Enterprise* library, which, in turn, is linked to computerized libraries throughout the galaxy. As in Jewish culture, studying, learning, and preserving knowledge are supremely important to Vulcans.

America has always had a sort of anti-intellectualism that values sports and "cowboy culture" over and above book learning. Neither of which I'm any good at. The other stereotype of Jews in the movies is that of the nerdy bookworm who is a bumbling idiot when it comes being a "real man" ala John Wayne. Which pretty much describes me. But once again, Spock broke the stereotype in a positive way. He is indeed an intellectual, but he is by no means incompetent as a Star Fleet officer. He can, if necessary, use a phaser with the best of them, and is an expert in Vulcan martial arts. And he does this while openly maintaining pride in his Vulcan culture.

More recently, I have realized that I relate to Spock in yet another way: As an autistic person. I have Asperger's Syndrome, and Spock's tendency to take things absolutely literally is something I also do. Roddenberry did not intend Spock as an autistic; he intended his literalism to be "logical." And I did not have this diagnosis back in the 1960s—Asperger's was not even on the radar until 1994—but thinking back, I did see myself in Spock that way. I also adopted his habit of turning insults into compliments or otherwise taking pride in ethnic mannerisms (or, in Spock's case, Vulcanisms) that people try to put down. My most recent instance of this was an encounter with a missionary who told me that, as a Christian, he was "free from the law" and did not observe the Sabbath the way we Jews do. "I'm very sorry to hear that," I replied. That silenced him. And I meant it. The Jewish Sabbath is filled with beautiful rituals and deep traditions handed down for millennia, not unlike the way ceremonies are kept in Vulcan culture.

Like Spock, I do not believe I need to give up my own culture or convert to something else in order to have a happy, fulfilling life. Spock grows and learns in the course of the series and the movies, but he does it within a Vulcan context. Similarly, I have found my place in the greater society while retaining my sense of Jewish Pride. And for that, I am very grateful to Leonard Nimoy. May his soul be always at peace in the spiritual Garden of Eden.

20

Making Mr. Spock's Ears

STEVE NEILL[19]

For years now, I've worked in the motion picture industry and I've worked on all kinds of movies, like Ghostbusters and Fright Night, doing props, prosthetic makeup, creatures, miniatures and more. Today, we run our own studio called SNG Studios, in Ventura, California, where we continue doing movie magic, effects, makeup, and even making our own sci-fi films. But my first love has always been Star Trek. In all the years I've worked in the motion picture business, there has never been a greater moment than the moment where I worked on Star Trek: The Motion Picture. How I came to work on the film is kind of an interesting story in itself.

I had met Gene Roddenberry and Majel off and on at conventions over the years, where was doing prosthetic makeup,

[19] This piece was edited by Kevin C. Neece and is a composite of Steve's recounting of this story in two separate videos.

and even Vulcan ear tips, and applying them to people. And, as time went by, I got to know them a little better and, somewhere along the line there, I ran into Fred Phillips, who was the man who did the makeup for the original Star Trek TV series. He did Leonard Nimoy's makeup and he did his ears. This makeup artist, this man, was a truly great guy. Everybody loved Fred. I think I speak for everyone who ever worked on Star Trek, who knew Fred. He was a terrific guy and a great makeup artist. And we became friends and helped each other in the business.

One day, I got a phone call from Fred he had this sort of gravelly voice and he said, "Hey Steve. You wanna work on Star Trek?" And I thought he was joking with me because there wasn't any Star Trek. I didn't even know they were planning a movie; I didn't know about Phase II. I said, "Fred, we talked about it, Star Trek's been off the air for years." And he said, "No, we're doing a Star Trek movie down here. Would you like to come work on it?" Well, of course, I practically hit the floor.

I was so excited. I was in my mid-20s and I'd always been a Star Trek fan, since the show first aired. In fact, I would never miss an episode when I was in high school. I would leave my girlfriend's house—she didn't like Star Trek—and run all the way home, three miles, to watch it on my little black-and-white TV, when my girlfriend's family had color! And, of course, my favorite character of all was Mr. Spock.

So I said, "Of course! Yes, Fred, I want to work on Star Trek!" So, he had me come to the studio and I remember my first day going down there. I went through those very same doors Leonard Nimoy had gone through every day. There we were, in that makeup room, the makeup room, the same makeup room, right off the same stage where Star Trek had been done in the first place all those years ago.

Fred walked out and I said, "What are we doing today, Fred?" He pulled out a little plastic bag and said, "You wanna re-create these?" and threw it on the table. Inside the bag were a pair of original, foam, prosthetic ears from the Star Trek TV show. They were brand new ones; they had never been worn, but they were left over from the original show. It was amazing to see the real ears. I'd seen plenty of Planet of the Apes appliances and

other famous stuff that was actually screen-used, but there were those ears, sitting right there. Even then, only seven or eight years after the show had gone off the air, those were really valuable and highly coveted by the fans. And here Fred was, asking me to re-create them. I was in heaven. What an amazing thing, what a full circle to come to, from watching the show in high school and thinking, "Gee, wouldn't it be neat to meet these people, or even meet Leonard Nimoy one day," to being in that position, where I was going to sculpt his ears.

So, Fred left me with the ears. He showed me a table to work on there and he brought out the ear castings that they'd already done of Leonard and put them on the table and said, "Well, there you go. Have at it." I said, "Wow, okay, great!" because his was something I'd always wanted to do. I started sculpting in the clay and I worked and worked on it. I really wanted to make them look exactly like the original sculptures that John Chambers had done. (John was someone else I worked with, who had done the Planet of the Apes makeup.) I didn't want them to be sort of like his; I wanted them to look exactly the way they did on the show and so I worked very, very hard at it and very, very long and I went over into the late afternoon, or maybe even the early evening.

It was somewhat dark in there. I didn't have all the lights on, just some lights overhead. I was working away and this shadow suddenly appeared, blocking my light. I thought it might be Fred, I didn't know what. And I heard this distinctive voice ring out, "Are those my ears?" And, even now to this day, I get this chill. I felt it all over my body because I realized that it was Leonard Nimoy behind me. I was sitting at the table, sitting low over my work, and I turned around and looked up.

There he was, towering over me like some sort of giant, backlit by the overhead light, with a big grin on his face. My voice wavered as I said, "Yes, sir, Mister Nimoy. Yes, these are your ears." And he said, "Very, very nice, young man," and walked off. That was my first introduction to Leonard. I've never forgotten that. What an amazing, amazing moment and something I always cherish and always remember.

Of course, later on, I was in the lab all the time and with Fred when Leonard was being made up and all the crew was there in full costume and everything, throughout the shoot. I remember being in the makeup room early in the morning at Paramount and there were Shatner and the entire crew, leaning up against the makeup tables, and Nimoy was sitting on top of one of the tables with one of his feet up, in full uniform, all made up, while Shatner was being made up by Fred and they were all telling jokes and stuff. I practically fainted. Talk about geeking out! I never got used to it! It was the best time of my life and I'll never forget it.

And I did other things on the show. I worked on an alien on the bridge, played by Billy Van Zandt, and on a lot of the background characters. I even helped with the creation and development of the Klingons and was there for the first Klingon makeup test. But that moment with Leonard and the ears was incredible. And what a kind, wonderful human being Leonard was. I was so lucky to have been able to work with him. I still have, to this day, copies of his ears and the original molds made from the sculptures I did on his ear castings.

What an amazing time. Gene Roddenberry, Robert Wise, and everybody else were just so incredible, but I can't thank Leonard enough for a great moment in my life that I remember every day and that is still the most thrilling moment in my entire career. Thanks, Leonard.

21

How Leonard Nimoy Saved My Life

T'Nara Valdrin Kelensa

This is a very personal story for me. Over time, I've grown more comfortable with sharing it, but since the passing of Mr. Nimoy, I have found I genuinely want to share it. I want the world to know just how impactful he really was on other people's lives.

When I was fourteen years old, I felt as if my entire world fell apart. Somebody I respected more than anybody else in the world, turned away from God and did things that made it blatantly clear he was not worthy of the respect and affection I had for him. It broke my heart, and I got angry and confused. And that one instance just became the first in a long domino effect of hurt and confusion. Before I had turned fifteen, I felt as if I had lost my hopes and dreams, my future, and all of my friends. I was lonely, convinced that I was worth nothing, and I hated myself.

And then to top it all off, the baby of a very close friend died. That just made it worse. I became suicidal. I thought that if not even a baby deserved to live, why did I? If I had no future, what did I have to look forward to? If all I had was loneliness and fear and anger and confusion, what was the point? To make matters worse, at that time my relationship with my mom became incredibly explosive, and she is the one who I *desperately* needed to help me through it. But because of the state of our relationship, I couldn't get that help.

And then I discovered Star Trek, Spock, and Mr. Leonard Nimoy, and I found somebody who could help. I had no future? Star Trek offered me one. Star Trek told me of a future where you could be or do anything. I was lonely? So was Spock. And Spock showed me that loneliness does not confine you, or keep you from being the best of yourself. And if you can be the best of yourself, you have accomplished *something*. And while I am forever grateful for Star Trek and Spock for giving me that, Mr. Nimoy gave me something more.

Losing somebody who I once respected is what started my emotional down-spiral, and finding somebody to respect is what started my healing. Mr. Nimoy gave me somebody who I could really truly respect. The more I read about him, the more I liked what I saw. I saw a man who was consistently (and accurately) described as being a man of great integrity. I saw a man who approached life with a level of passion and intellect that inspired me. I saw a man who took time out of his busy schedule to write to a little bi-racial girl who identified with Spock. I saw a man of kindness and humility. I saw a man who gave of himself time and time again and took great joy in that. It is reflected in his poetry. "Whatever I have given, I have gained,"[20] he wrote in "A Time to Give." And, later in that same poem, "When you let me take I'm grateful. When you let me give I'm blessed."[21] "The

[20] Nimoy, Leonard, "A Time to Give," *A Lifetime of Love: Poems on the Passages of Life*, SPS Studios, Inc., 2002.
[21] *Ibid.*

miracle is this:" he wrote elsewhere, "The more we share the more we have."[22]

I hated myself, and he gave me somebody to aspire to be like. The more I learned about him by reading both what he had written and what others had written about him, the more I was inspired. I saw his intelligence and how much he valued it, and strove to emulate it. I saw his creativity and it reawakened my own creativity and love of art, and I no longer felt as if I had nothing to offer the world. I saw the way he looked at the world, and it changed the way I looked at it. I saw the way he looked at other people, and began to look at myself that same way.

Honestly, the greatest compliment I have ever received, which is a sort of culmination of all of this, was when a friend told me that if my goal was to rise to the same level of intellect, passion, kindness, and integrity that I saw in Leonard Nimoy, I most certainly succeeded.

Leonard Nimoy saved my life. There are no two ways about it. I am firmly convinced that I would not be alive today if not for his influence. And I want people to know about that. He was never just "the guy with the pointed ears", not to me at least. That was just one single facet of who and what he was to me and everybody else that he was able to touch throughout his long and prosperous life. He's best known to the world at large as Mr. Spock, but he is loved for being so much more.

[22] Nimoy, Leonard, "You And I Have Learned," *These Words are for You,* Blue Mountain Arts, 1981.

22

Being Leonard Nimoy

NEIL SHURLEY[23]

Somewhere around third grade, I developed a habit of clasping my hands behind my back, "at ease"-style. I took to saying "Fascinating" whenever the situation even vaguely warranted it. And if I squinted one eye and tilted my head, I could just about fake raising a single eyebrow.

Armchair psychology tells me I identified with Spock because I, too, was the "other," the outsider, the new kid. But come on - the logic, the dry humor, the ears. What's not to love?

As I watched *Star Trek* reruns after school, my loyalties sometimes shifted. Kirk was the best. Scotty was the best. I even underwent a long stretch of naming the seldom seen transporter

[23] This piece was originally published in the April/May 2015 issue of *Shelf Unbound* at http://issuu.com/shelfunbound/docs/shelf_unbound_april-may_2015 and is reprinted by permission.

chief Lt. Kyle as my favorite. But I always came back to Spock, the science officer, the emotionless, super-competent alien.

Eventually, the show itself was not enough. So I bought books. Armed, for the first time, with money that was actually my own - earned by cashing out a savings bond given to me by my grandfather - I begged my mother to drive me to the mall. I made a beeline for Waldenbooks (or was it B. Dalton?) and left with three precious volumes that remain on my shelf today - *The Making of Star Trek*, *The World of Star Trek*, and *The Trouble With Tribbles*.

I devoured them, relishing the reprinted memos, the stories of backstage pranks, and the myriad details that emerged from inside the production. The life I read about on the soundstage was almost as interesting as life depicted on the Enterprise. Pretty soon, though, I started reading boy detective novels and my imaginative adventures began to change.

Yet Leonard Nimoy remained.

As an obsession with bigfoot and the Loch Ness monster and *Chariots of the Gods* took root, Nimoy appeared on TV to fuel it. *In Search Of...* provided an infuriatingly catchy theme song as well as frightening speculation behind mysteries that, when looked at now, don't seem all that mysterious. Yet it pushed me to read even more, to explore, to weigh the evidence for myself.

I discovered Nimoy's memoir, *I Am Not Spock*. Inside were photos of the actor in other roles. I was particularly taken by his appearance as King Arthur in *Camelot*, and vowed that I, too, would one day play that role.

Nimoy starred in *Mission: Impossible* for two years, including the single most memorable – to me – episode of the entire series, "Submarine."

He wrote and starred in an acclaimed one-man play about the brothers Vincent and Theo Van Gogh. I followed news of it and could not wait to see the videotaped version run on HBO.

He recorded albums that I both treasured as cheese and fully enjoyed. One song, "You Are Not Alone," from his debut album, *Leonard Nimoy Presents Mr. Spock's Music From Outer Space*, became one that I introduced to college friends. They found it hilarious while also joining me in singalongs.

After watching the first several episodes, I gave up on William Shatner's cop show, T.J. Hooker. But I tuned back in for Nimoy's guest appearance.

I memorized a poem from one of Nimoy's numerous poetry collections. Common wisdom says everyone should know one poem by heart, and mine is titled "Rocket Ships Are Exciting." I once shouted it aloud, over and over again, from the back of a parade float we titled "Trailer Full o' Poets."

When I spotted a memoir by Adam Nimoy, Leonard's son, I instantly bought it and read it, heartened to learn that Nimoy was fully human, a good if sometimes too career-driven father.

I still find myself clasping my hands behind my back, Spock-style. If someone flashes me a peace sign, I respond with the Vulcan salute. One of my very few pieces of original art is a framed line drawing of Spock.

I guess all of these things, taken together, begin to explain why, for the first time in my life, I cried at the death of a celebrity.

Though I've yet to play King Arthur, I did get to perform another role that was, in the long run, much more memorable for me. While still in high school, I put together a cutting from the book *I Am Not Spock* that encompassed several imagined dialogues Nimoy devised between himself and his alter ego. I performed the piece for a statewide "solo acting" competition. For those few minutes on stage I became, quite literally, both sides of my hero. It ended with this:

> NIMOY: Don't forget that I'm real and you're only a fictitious character.
>
> SPOCK: Are you sure?

www.ingramcontent.com/pod-product-compliance
Lightning Source LLC
Chambersburg PA
CBHW051810170526
45167CB00005B/1957